BRUSH PEN
ILLUSTRATION

Brimming with creative inspiration, how-to projects, and useful information to enrich your everyday life, Quarto Knows is a favorite destination for those pursuing their interests and passions. Visit our site and dig deeper with our books into your area of interest: Quarto Creates, Quarto Cooks, Quarto Homes, Quarto Lives, Quarto Drives, Quarto Explores, Quarto Gifts, or Quarto Kids.

FUDE PEN ILLUST RENSHUCHO (Boutique Mook no. 958)
©2011 Boutique-Sha, Inc.
All rights reserved.
Originally published in Japanese language by Boutique-Sha, Tokyo, Japan
English language rights, translation & production by World Book Media, LLC
Email: info@worldbookmedia.com

First published in the United States of America in 2018 by
Quarry Books, an imprint of
The Quarto Group
100 Cummings Center
Suite 265-D
Beverly, Massachusetts 01915-6101
Telephone: (978) 282-9590
Fax: (978) 283-2742
QuartoKnows.com

Quarry Books titles are also available at discount for retail, wholesale, promotional, and bulk purchase. For details, contact the Special Sales Manager by email at specialsales@quarto.com or by mail at The Quarto Group, Attn: Special Sales Manager, 401 Second Avenue North, Suite 310, Minneapolis, MN 55401, USA.

10 9 8 7 6 5 4 3 2 1

ISBN: 978-1-63159-500-4

Translator: Kyoko Matthews
English Language Editor: Lindsay Fair
Design: Nicola DosSantos

Printed in China

About the Author

Sho Ito was born in 1967 in Japan. Ito is an award-winning artist known for his ink painting work. He has exhibited his work internationally and is the author of several books about brush painting.

BRUSH PEN
ILLUSTRATION

More Than 200 Ideas for Drawing with Brush Pens

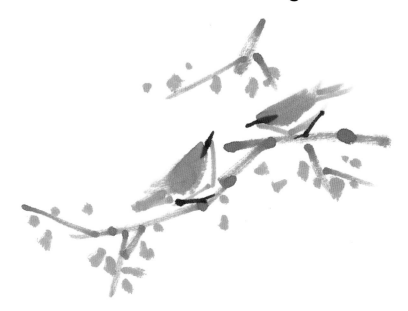

Sho Ito

INTRODUCTION

Ink brush art and calligraphy have been practiced in Asia for thousands of years. Traditionally, ink sticks are ground on a stone and mixed with water, and then a brush is used to apply the ink to paper. Although preparing ink this way is a beautiful and authentic part of brush illustration, it can be prohibitive to new artists.

Today's brush pens allow artists to create colorful, painterly illustrations without the mess and expense associated with traditional brush and ink. Brush pens create gentle illustrations that are full of expressive movement.

This book contains over 200 different illustrations, from fruits and vegetables to animals and automobiles. Each drawing is broken down into simple steps so you can practice the lines and movements. Once you master these techniques, I hope you are inspired to create your own original illustrations.

—Sho Ito

Strawberry Shortcake
(see page 34)

Camellia
(see page 83)

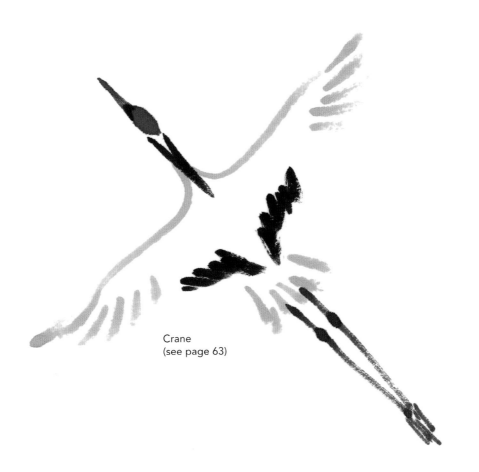

Crane
(see page 63)

Turban Shell
(see page 71)

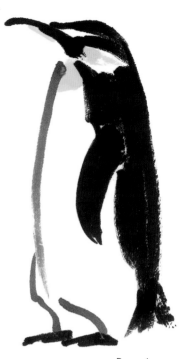

Penguin
(see page 65)

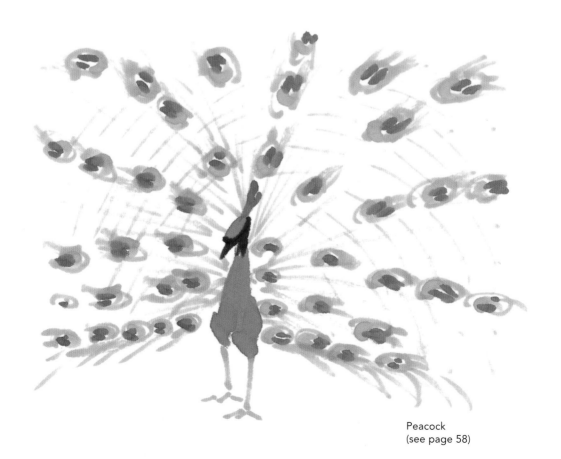

Peacock
(see page 58)

CONTENTS

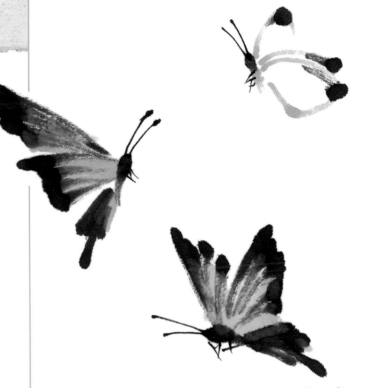

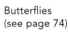

Butterflies
(see page 74)

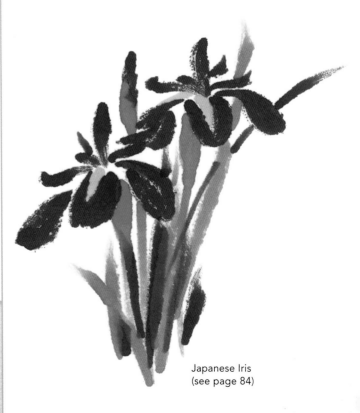

Japanese Iris
(see page 84)

ABOUT BRUSH PENS

Brush pens have been used as writing instruments for thousands of years. There are many different styles and colors of brush pens available today, making them an excellent tool for illustration.

Brush pens are classified by the style of their tips: hard tip, soft tip, and brush tip. Hard and soft tip pens have relatively firm felt tips, allowing for greater precision and control, while brush tip pens have flexible hair tips (either synthetic or natural) that perform more like paintbrushes.

I recommend trying various types of pens with different degrees of flexibility and thickness until you find the kind that feels most comfortable and suits your personal style of illustration. The following guide explains each of the three basic brush pen types in detail.

Hard Tip

This type of felt tip pen is great for small drawings or details within a larger illustration, and can also be used for calligraphy. Hard tip pens have firm felt brushes that feel like markers and are easy to control, but don't produce as much of the soft, flowing texture associated with brush pens.

"Bimoji" is a Japanese word for beautifully written Asian characters.

Kuretake Bimoji Brush Pen (Extra Fine)

This pen possesses a thin, durable tip and is designed for writing Asian characters. In fact, the plastic bodies were designed to resemble lightweight bamboo brushes. Use this pen for fine details or patterns.

Kuretake Zig Letter Pen Cocoiro (Extra Fine)

Despite their hard tips, these cute little pens are surprisingly flexible and make drawing easy. Plus, they're available in several different colors. Note that the pen body is sold separately from the combination brush tip and ink cartridge in this line of pens.

Soft Tip

Similar to hard tip pens, these pens possess more flexible felt tips that allow you to adjust line thickness as you draw by changing the pressure of your strokes against the paper.

Kuretake Bimoji Brush Pen (Broad)

This pen features a very elastic tip, which lets you easily modulate the pressure of your brush strokes and create drawings with plenty of line variation. You'll have a lot of fun with this pen!

Also available in metallics!

Kuretake Fudebiyori Brush Pen

These vibrant pens are as easy to use as markers, but also produce the beautiful line variations associated with traditional brushes. These pens feature water-based, dye-based ink that can be blended with a water brush to create watercolor effects (see page 11). They're available in 24 colors, plus six metallic shades, which are made with water-based pigment ink.

Brush Tip

This type of pen most resembles traditional brushes, and features a very soft brush tip made of synthetic or natural hairs that "squish" against your paper when you apply pressure. Use the side of the pen tip as you draw to create rough brush strokes, or to fill areas with color.

Kuretake Bimoji Brush Pen (Medium Bristles)

This pen's soft, springy tip is very useful for creating textured lines. It uses a water-based pigment ink, which becomes water-resistant once it dries.

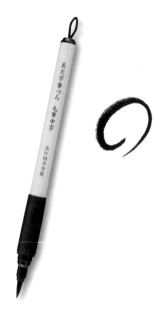

Kuretake Sumi Brush Pen (No. 31)

This pen features a lighter shade of black ink that can be used to provide contrast to darker black pens.

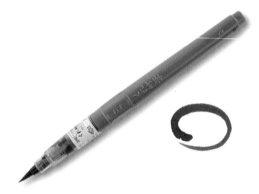

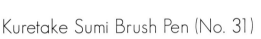

Author's Recommendation!

Kuretake Zig Clean Color Real Brush Pens

The soft bristle tips on these pens can be used for a wide range of techniques, from drawing thin lines to filling in large areas. They feature water-based, dye-based inks that can be blended with water, and are available in 60 colors.

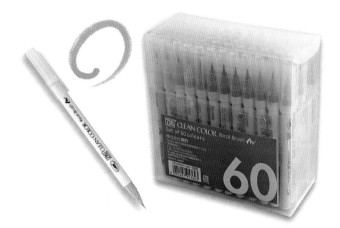

Water Brush Pens

Water brush pens add a beautiful watercolor effect to illustrations without the mess and hassle associated with using a cup of water and traditional paintbrush. Simply fill the pen barrel with water, and then squeeze to moisten the brush and apply water directly to your illustrations. Use the brush to blend your lines into soft, painterly shapes. Just remember, this technique will only work on illustrations made with water-soluble ink, so check your pens first!

How to Use a Water Brush Pen

Kuretake Water Brush

Water brushes are available with both round and flat tips.

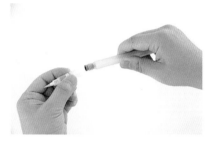

1. Unscrew the barrel.

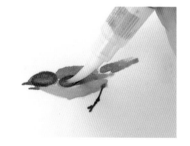

2. Fill the barrel with water. You can either suction water up from a glass, or fill it up from a tap.

3. Screw the brush tip back onto the barrel. Gently squeeze the barrel to push the water through the brush.

4. Apply the wet brush directly to a brush pen illustration you've already created. Use the brush to blend the ink.

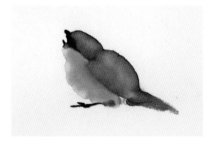

5. Let the illustration dry completely.

Water Brush Techniques

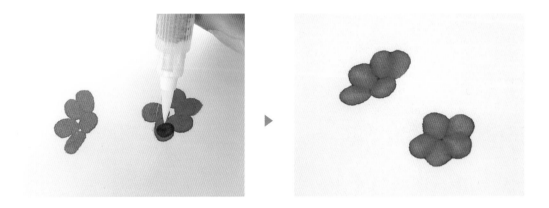

To create a soft, painterly effect within a small area of the drawing, hold the water brush upright and apply the tip of the brush to that specific spot.

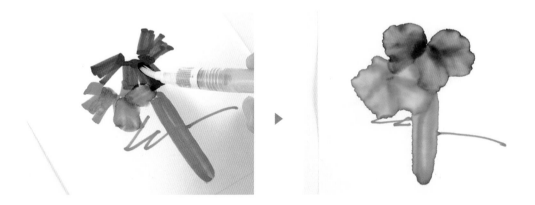

To create a soft, painterly effect throughout a large area of the drawing, hold the water brush at an angle so that the broad side of the brush meets the page. Trace over the illustration using steady strokes.

ABOUT PAPER

The illustrations in this book were made on Xuan paper. This traditional Chinese paper is renowned for its soft, fine texture and has been used for calligraphy and painting since ancient times.

The type of paper you use will influence the final appearance of your illustrations, so try using different papers until you achieve your desired look. The following guide compares several different types of paper that work well with brush pens. The same image was drawn on each type of paper for comparison.

Xuan Paper

Also known as rice paper, this absorbent paper allows for expressive brush strokes and vibrant displays of ink.

Cardstock

This heavyweight paper is slightly less absorbent than Xuan paper, so it doesn't allow for a lot of blending when used with a water brush.

Stationery

Look for a lightweight paper with a rough surface that will catch the brush tip as you draw. This type of paper will produce illustrations with a soft impression.

Copy Paper

Since the surface of copy paper is quite smooth, it can be difficult to create rough lines, unless you move your brush quickly. This type of paper is not very absorbent, so it can be difficult to spread color using a water brush.

BASIC BRUSH PEN TECHNIQUES

Before we get started creating illustrations, let's master the basic techniques of using brush pens. The following guide will teach you how to draw dots, make lines, and fill illustrations with color.

Dots

Dots are really simple to make: Just place the tip of your brush pen on the paper and press down. Change the amount of pressure on the pen or apply movement to make dots of different shapes and sizes.

Round Dots

These dots are the simplest to make. If your paper is absorbent, you can hold the pen tip in place for a few seconds; otherwise, rotate your pen to increase the size of the dot.

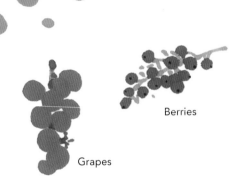

Berries

Grapes

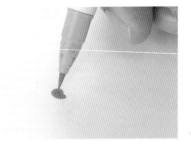

1. Lightly place the tip of the brush on the paper.

2. Gently rotate the pen, keeping the tip on the paper.

Flicked Dots

This type of dot features a wispy tail that results from flicking the brush upward and away from the paper. The dot size will change depending on how quickly you move the brush.

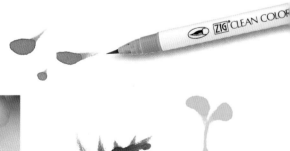

Ginkgo leaf

Thistle leaf

1. Place the tip of the brush on the paper.

2. Briskly flick the pen upward.

Long Dots

These bold dots have an oval shape. Changing the amount of pressure as you move your pen will change the size of the dot, or even give it a tapered point.

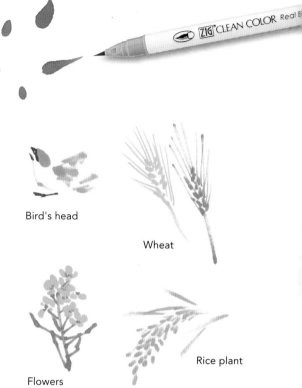

1. Place the tip of the brush on the paper.

2. Press down firmly and move the pen to the side, keeping the tip on the paper.

Bird's head

Wheat

Flowers

Rice plant

More complex images will combine multiple types of dots.

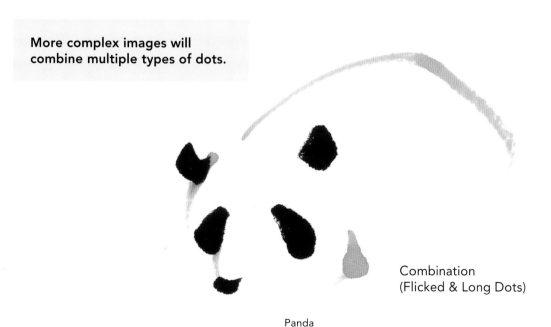

Combination
(Flicked & Long Dots)

Panda

Lines

To draw a basic line, simply place the tip of your brush pen to a sheet of paper and then move it across the page. By changing the amount of pressure you apply to the pen, you can draw a great variety of lines. The following guide showcases a few different line techniques used in this book.

Uniform Line

Visualize the brush tip as the center of your line, tilt your pen slightly, and pull it across the page in a straight line. This type of line requires the same, steady amount of pressure from beginning to end. Light pressure makes a thin line, while heavy pressure creates a thick one.

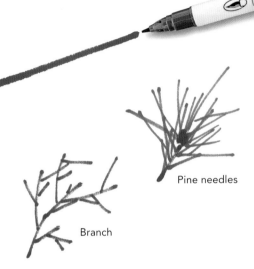

Pine needles

Branch

1. Tilt your brush slightly and place its tip on the paper. Then move your pen slowly to draw.

2. Keep your wrist locked and draw using your entire arm. Apply a steady amount of pressure to your pen.

Tapering Line

Begin drawing your line firmly, and then ease up on the pressure as you go to make it taper at the end. Depending on how much you loosen your grip, you can achieve sharp or scratchy textures in your lines.

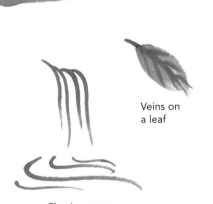

Veins on a leaf

Flowing water

Ribbon

1. Place the tip of your brush to the paper. Apply pressure until the entire tip is touching the paper.

2. Gradually decrease pressure as you draw, then lift your pen up at the end of the line.

Undulating Lines

These lines are created by varying the pressure in a single brushstroke. You can create bumpy or smooth undulating lines.

Bumpy

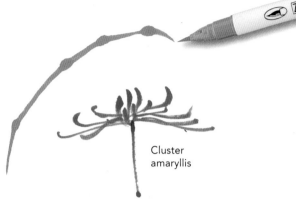

Cluster amaryllis

1. Start off with a loose grip on your pen. Increase pressure as you draw, then stop without lifting the pen. This will allow the ink to absorb into the paper, creating a bump.

2. Loosen your grip on the pen again and continue drawing. Repeat steps 1 and 2, alternating as desired.

Smooth

Magnolia flower

1. Begin drawing with a firm grip, then loosen up as you go. Make sure to keep the pen moving!

2. Increase pressure on your pen again as you continue to draw. Repeat steps 1 and 2, alternating as desired.

This image combines both tapering and undulating lines.

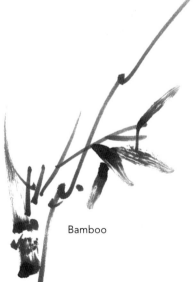

Bamboo

Coloring

By changing the number or brushstrokes or the speed of your movement, you can produce different results when coloring your illustrations. The following guide explains three coloring techniques used throughout this book.

Single Stroke Coloring

This technique uses the side of the brush to produce a single measured stroke. Move the brush slowly to create a beautiful, smooth surface.

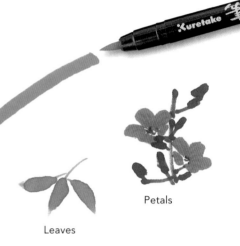

Leaves

Petals

1. Angle your brush by holding the middle of the pen. Then lay the side of the brush tip onto the paper.

2. Slowly move your brush pen across the page.

Multiple Stroke Coloring

Use multiple brushstrokes to fill large areas with color. Move your brush in the same direction each time for a consistent look. Adjust the amount of brushstroke overlap to produce different textures.

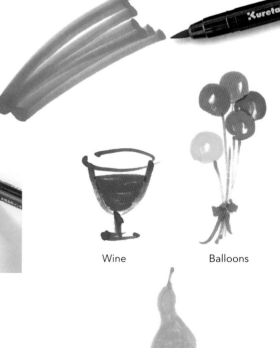

Wine

Balloons

Gourd

1. Angle your brush by holding the middle of the pen. Then lay the side of the brush tip onto the paper, and slowly move it sideways.

2. Repeat step 1 as desired.

Rough Coloring

For a dry, scratchy effect, lightly place the side or very tip of your brush on the paper, and then quickly drag it back and forth. This will give your illustrations a dramatically textured look.

1. Holding the middle of the pen, lightly place just the tip of the brush on the paper, then move it quickly from side to side.

2. Repeat step 1 as desired.

Bark

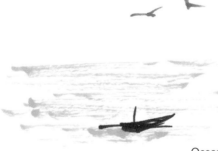

Ocean

Champagne

FOOD

Let's start out by drawing some everyday foods, like vegetables, fruits, and sweets. These simple shapes have a truly unique look when you draw them with brush pens!

Vegetables

Let's capture specific characteristics like roundness and bumpiness as we draw these vegetables. You'll learn how making different movements with the pen can create variations in texture.

Eggplant

 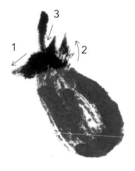

Start with a gradual curve.

Use another curve to complete the teardrop-shaped eggplant body.

Use quick brushstrokes to depict the roughness of the eggplant's dried up leaves and stem.

Corn

 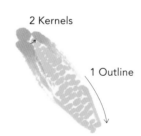

Draw a small square for the base.

Use a quick brushstroke for the husk.

Repeat on the other side.

Draw the corn kernels in rows. Leave a little white space between each one to make them look plump and shiny.

Green Pepper

 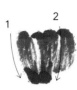 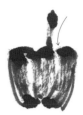

Use the side of your brush tip and draw each section with a quick, rough brushstroke.

Draw several sections that connect at the top and bottom of the pepper.

Outline your brushstrokes with curved lines to give your pepper more volume.

Variation

Use orange or yellow to make different types of peppers. Use the same technique, but make your vegetable short and squat to create an acorn squash!

Daikon Radish

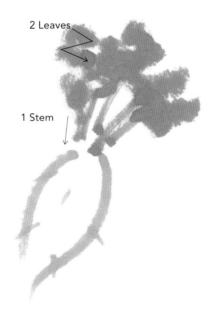

2 Leaves

1 Stem

Use the tip of your brush for gentle, curved lines.

Roots

Add light, wispy lines for the roots.

For the greens on top of radish, tilt your brush pen and move it across the page in zigzags.

Variation

Change the color for a red daikon.

Potato

Outline the potato's shape with an undulating line. Pause occasionally and let the ink absorb into the paper, creating bumps and lumps.

Use rough, curving brushstrokes to fill in the potato's knobby skin.

Use dots for the potato's "eyes."

Japanese Yam

Use two bold, arching brush-strokes to outline the yam.

To color in the yam, angle your pen and use rough, zigzagging brushstrokes.

Roots

Add a few roots to your yam for a natural, freshly dug look!

Carrot

Use the side of your brush to draw a curved line for a three-dimensional carrot.

Tilt your pen and move it lightly across the paper for a thick, textured brushstroke. Make your strokes curve around the carrot's form to add volume.

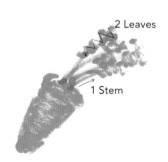

2 Leaves

1 Stem

Move your pen quickly in tight zigzags to suggest the tiny leaves on top of the carrot.

Bamboo Shoot

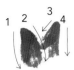

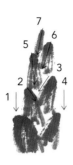

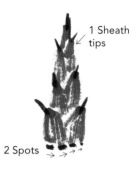

1 Sheath tips

2 Spots

Draw the bamboo shoot's tough outer sheaths with inverted V shapes.

Use two lines to draw the wide sheaths at the bottom of the shoot—the shorter sheaths at the top only need one.

Short, pointy lines and scratchy brushstrokes are perfect for capturing the texture of an unpeeled bamboo shoot.

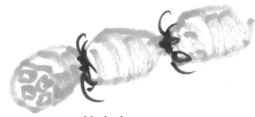

Variation

Lotus roots grow linked together in chains, so try drawing them that way too!

Lotus Root

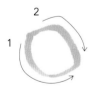

Start with a tilted circle for the flat cross-section of a sliced open root.

Add some circles for the holes.

Outline the rest of the lotus root. Use rough zigzagging brushstrokes for the surface.

Onion

Use tapering brushstrokes to outline the onion's bulbous shape.

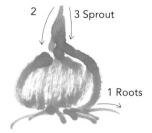

Use rough vertical brushstrokes to capture the texture of the onion's papery skin.

Add a pointy green sprout at the top and thin roots at the base.

Cucumber

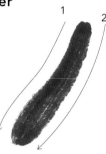

Use the side of your brush to draw the whole cucumber with two gently undulating brushstrokes.

Make the end of the cucumber slightly wider, and then add some darker dots for bumpy skin.

Burdock Root

Keep your wrist locked and use your entire arm to draw the root in one continuous brushstroke.

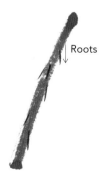

Use the tip of your pen to add black feathery lines for the small roots. Out of all the vegetables, the burdock root is probably the simplest to draw!

Spring Onion

When drawing the leaves, start out applying heavy pressure and ease up on your pen as you go.

Draw each leaf moving quickly from top to bottom.

Draw the bulb with gentle, tapering brushstrokes, and leave it uncolored.

Napa Cabbage

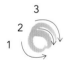

Use short, curved brushstrokes for the circular base of the cabbage.

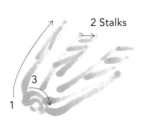

Use quick, diagonal lines for the leaf stalks.

Leaves

To draw the napa cabbage's tight, curly leaves, angle your brush and make short, rough brushstrokes.

Variation

Use thick, uniform brushstrokes for the leaves to draw Japanese mustard spinach.

Fruit

Since most fruits are composed of round, simple shapes, they make wonderful subjects for brush pen illustration. Many of the basic brush pen techniques shown on pages 14-19 will be used to replicate the texture of the fruit's skin and seeds.

Strawberry

Use two strokes to draw a tapered oval.

The seeds are created with long dots arranged in a vertical pattern.

Use flicked dots for the hull.

Apple

Draw a small curve for the core.

Use two strokes to draw a heart shape.

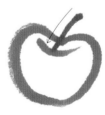

Add the stem.

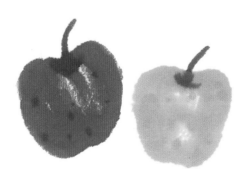

Variation

Fill in the apple using rough lines, and then add dots in a different shade to capture the look of an apple's skin.

Cherries

Hold your pen at an angle and use the broad side of the brush to draw a circle for each cherry.

Add the stems.

Tip

Keep the scale small for a cute impression.

Banana

Draw a T shape for the stem.

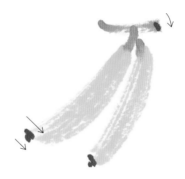

Hold your pen at an angle and draw each banana from top to bottom in a single stroke.

Add brown dots to the tips of the bananas and stem.

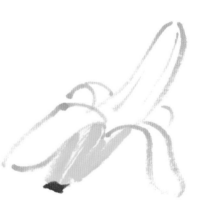

Variation

Use gently curved lines for a peeled banana.

Clementine

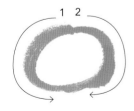

Use two strokes to draw a flattened oval.

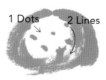

1 Dots 2 Lines

Hold your pen at an angle and quickly draw thick lines to emphasize the curved shape of the fruit. Add some dots for texture.

Add a small leaf to the top.

Watermelon

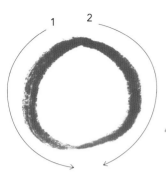

Use two strokes to draw a circle.

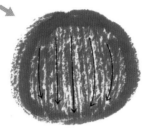

Use vertical strokes to fill with color.

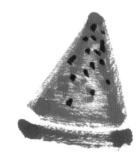

Variation

For a wedge of watermelon, draw a green rind with one quick stroke. Leave a bit of white space, and then draw a red triangle on top. Don't forget the seeds!

Zigzag pattern

Use a darker shade of green and move the pen from side to side as you draw to create a striped zigzag pattern.

Melon

Draw a T shape for the stem.

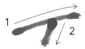

Fill with skin color

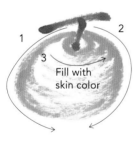

Use two strokes to draw a circle, and then fill with color.

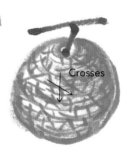

Crosses

Outline the melon with a darker shade of ink and cover the skin with random cross marks.

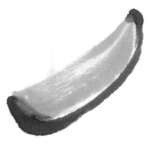

Variation

For a slice of melon, draw a shallow curve and then fill with color. Orange and green work well for cantaloupe.

Peach

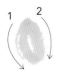

Use the side of your brush to draw the smaller peach section with two rounded brushstrokes.

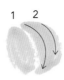

Draw the larger peach section with longer, more curved brushstrokes. Make sure to leave a bit of white space between the sections.

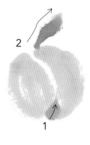

Add a green leaf and a touch of brown at the base of the fruit.

Pear

Draw the outline with an undulating brushstroke, changing pressure as you go. Use angular brushstrokes rather than gentle curves.

Fill in the outline with slightly curved, rough brushstrokes.

Add a brown stalk to the top.

Blueberries

Start with a rough, semicircular brushstroke.

Outline the side of the berry and add a little circle at the top, making sure to leave a bit of uncolored space for the hull.

Variation

Arrange several blueberries in a cute little pile.

Persimmon

Start with the stem.

Dried leaves

Draw the leaves radiating outward from the center point, which is also the stem.

For the fruit itself, use a wide, swooping brushstroke that wraps around the leaves.

Variation

The two most common types of persimmons are the Hachiya and the Fuyu. The Hachiya is shaped like an acorn and is incredibly tart until it is ripe—then it becomes extremely sweet. The Fuyu is shaped like a tomato and tastes like a crisp apple.

Pineapple

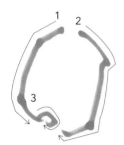

Outline the pineapple with angular brush-strokes, leaving some space open at the top and bottom. Draw a small circle at the base.

Patterned skin

Lay down diagonal rows of short brushstrokes for the pineapple's distinctive scaly skin. Leave space around each diamond.

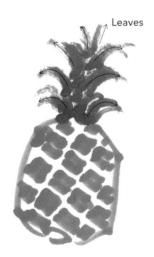

Leaves

Use quick upward brushstrokes to capture the spikiness of the pineapple's leaves.

Fig

Start with a curved line.

Complete the outline, and then add shorter, rough brushstrokes curving over the surface of the fig. The green brushstrokes should travel from top to bottom.

Fill the bottom half of the fig with purple brushstrokes that travel from bottom to top. The colors will overlap beautifully to create a third shade!

Variation

Try drawing a fig that's sliced in half and ready to eat. Include some individual seeds for a realistic look.

Kiwi

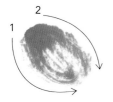

Use rough, curved brushstrokes for the flat, oval surface of the sliced open kiwi fruit.

Add several overlapping brushstrokes for the kiwi's furry skin.

Seeds

Add a ring of tiny oval seeds to complete the sliced kiwi fruit.

Sweets

With unique shapes and colorful details, dessert is as fun to draw as it is to eat! Let's draw cookies, cakes, and other favorite sweets!

Tip

Use the side of your brush to create solid shapes rather than a thin outline. Go slow so your brushstrokes are smooth.

Pudding

Use three horizontal brushstrokes to draw a trapezoid.

Add darker shading at the top.

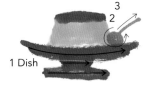

1 Dish

The dish is drawn with three strokes. A cherry provides a colorful accent.

Gelatin

1　2

Draw two curves that connect at the center.

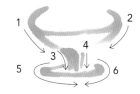

Add an inverted triangle and a small circular base.

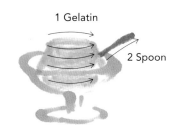

1 Gelatin

2 Spoon

If you leave some areas uncolored, it will give your gelatin a translucent look.

Ice Cream Sundae

Draw two curves that connect at the center.

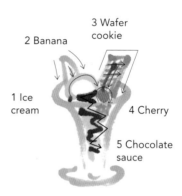

Add a long inverted triangle and a small circular base.

Tip

Smooth, unconnected lines help make the glass look transparent.

2 Banana

3 Wafer cookie

1 Ice cream

4 Cherry

5 Chocolate sauce

Fill up your dish! Once you decide where to draw the scoops of ice cream, arrange the other toppings in a way that keeps your dessert looking balanced.

Tip

Take care to leave some space between points 1 and 2 so you can draw the ice cream itself!

Macaron

Draw two curves to create the top cookie layer. The top should be extra thick to give the macaron some volume.

Use a curve to add the bottom cookie layer.

Variation

An assortment of macaron flavors, like green for matcha and brown for chocolate, can make quite a cute illustration. Use different colors to create unique cookie and filling combinations.

Strawberry Shortcake

Use two strokes
to draw a
rounded triangle.

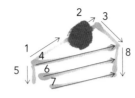

Draw a triangle around
the strawberry, and then
add three-dimensional
layers underneath.

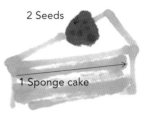

2 Seeds

1 Sponge cake

Hold your brush at an
angle as you draw the
layers of sponge cake.

Variation

Arrange a slice of cake on a
plate and add a cup of coffee
for a delicious dessert scene.

Tip

**Draw the layers of icing with
parallel, even lines. Keep your
wrist straight and move your
entire arm as you draw.**

Cupcake

Draw a bumpy
semicircle for the upper
edge of the frosting.

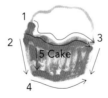

5 Cake

Add the cake
underneath
the frosting.

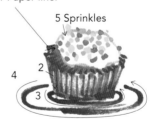

1 Paper liner

5 Sprinkles

You can suggest the zigzag
shape of the paper liner with
a second, darker color. Next,
make your illustration pop
with some colorful sprinkles.

Tip

**Use a thin wavy line
to outline where the
frosting meets the cake.**

Cake

Draw two curves that connect at the center.

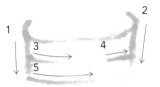

Add three-dimensional layers underneath, keeping the cake's round shape in mind.

Decorate the top with strawberries.

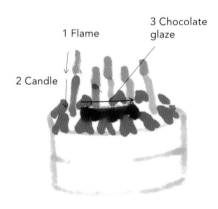

1 Flame
2 Candle
3 Chocolate glaze

Add some multicolored candles and your cake is birthday-ready!

Baumkuchen

This layered German cake resembles the rings of a tree trunk. First, draw three rings to create a light circular top layer.

Next, add darker rings with the tip of your brush.

Tip
The strawberries closest to the viewer should be the largest in order to emphasize the cake's roundness.

The following sweets are popular desserts in Japan.

Taiyaki (Fish-Shaped Cake)

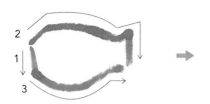

Outline the fish.

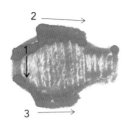

Add the fins, and then roughly fill with color.

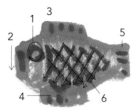

For a crispy, toasted look, add dark brown lines on top of the lighter base color.

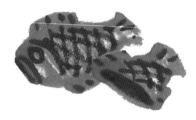

Variation

Try drawing your taiyaki at an angle. You can even draw one sliced in half to show the sweet filling.

Shaved Ice

Connect two curves for the rim of the dish.

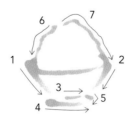

Draw the rest of the dish with fast, tapering lines that don't completely connect to suggest transparent glass. Use an undulating line for the pile of shaved ice.

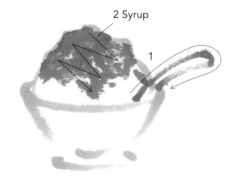

Draw the syrup with the side of your brush. Move it in a quick zigzag for a rough, broken line that suggests the texture of the shaved ice beneath the syrup.

Sakura Mochi (Cherry Blossom Rice Cake)

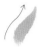

Draw the cherry leaf, tapering the line at the end by easing up pressure on your pen.

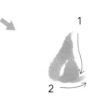

Fill out the leaf to make it thicker at the base.

Mochi

Use little pink dots for the mochi itself.

Add some dimension by drawing a slightly darker vein to the leaf.

Variation

You can change the color and shape of your dumpling to turn it into a kashiwa mochi, which is a rice cake wrapped in an oak leaf.

Kusa Dango (Grass Dumplings)

Use subtle curves to draw the red bean paste topping.

Draw the sweet grass dumplings with a circular stroke using the side of your brush.

These dumplings are usually served on a wooden skewer.

Variation

By changing the color of your dumplings, you can turn them into delicious toasted mitarashi dango, which are dumplings coated with a sweet soy sauce glaze.

Dorayaki (Stuffed Pancake)

Draw a thick top layer and a thin bottom layer, just like the macaron on page 33.

Draw the red bean paste last with a quick stroke of the pen.

Tip

The top pancake layer curves over the thick filling.

Anmitsu (Fruit Jelly)

Draw a semicircle for the dish.

Fill the dish with rectangles to create clear cubes of jelly.

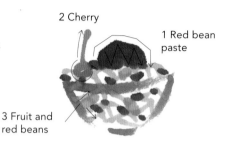

2 Cherry

1 Red bean paste

3 Fruit and red beans

Add a generous dollop of sweet red bean paste and a cherry on top. Then use two different colors of dots to add fruit and red beans to the jelly.

Oshiruko (Red Bean Porridge)

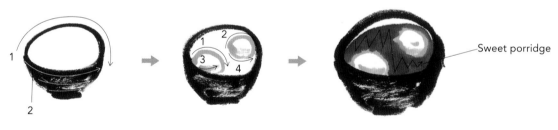

Sweet porridge

Draw a circle, and then use three strokes to draw the base of the bowl underneath.

Draw small circles inside the bowl.

Use the tip of your brush to fill in the rest of the porridge.

Tip
To draw the rim of the bowl, tilt your brush and make a quick stroke.

Sweet Buns

Draw two circles. Fill one circle, but leave the other empty.

Fill the sliced bun with dark red bean paste.

Tip

Don't just draw a flat circle for the bun! Make sure its surface looks rounded too.

Variation

Add a traditional Japanese teacup and tea whisk for an elegant illustration.

Konpeit Candy

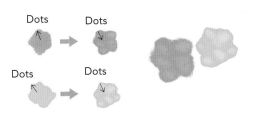

Draw a cluster of dots in a single color. Next, add a dot of a lighter shade of the same color on top of each existing dot. This will suggest the nubbly surfaces of these fancy traditional sugar candies.

Variation

Fill a bowl with candies of all different colors.

Meals

Drawing an entire meal may seem difficult, but once you learn the proper order, it's actually very easy. Take a moment to picture some of your favorite dishes, and then start drawing!

Fried Egg

Draw a yellow oval for the yolk.

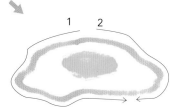

Draw a wobbly line for the edges of the egg white.

Variation

Here's a colorful and healthy breakfast with some broccoli and carrot slices on the side of a fried egg.

Toast

Draw a slanted rectangle.

Use scratchy lines to mimic the toasted surface of the bread.

Variation

Add a jar of strawberry jam to complete the breakfast!

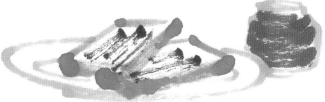

Variation

Grilled fish pairs nicely with a
bottle of sake and matching cup.

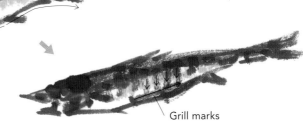

Grilled Fish

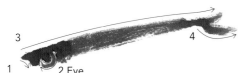

Draw the nose and
eye. Next, make a
single quick stroke
with the side of your
brush for the back
of the fish. Add a
V-shaped tail.

5 Fins

6 Body

Fill in the lower half of the
fish. Add the fins and gills.

Grill marks

After laying down a light gray surface
for the body, add some brown stripes
to give the fish a grilled look.

Tip

**Vary the pressure of your line as you
draw the stomach to make it look round.**

Edamame

Draw three circles for
the individual soybeans.

Enclose the soybeans
in a narrow pod.

Variation

Edamame is a popular bar
snack in Japan. Pair a bowl of
edamame with a mug of beer.

Sushi

Use subtle curves to
draw the piece of fish.

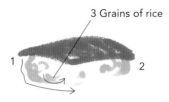

3 Grains of rice

You only need to draw
a few grains of rice
to suggest the whole
shape of the sushi.

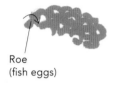

Roe
(fish eggs)

Use small circles and
curves to create a
dollop of roe.

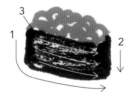

Use rough lines to draw
the nori, or seaweed,
underneath the roe.

Variation

Arrange several different pieces of sushi on
a tray for an impressive presentation. Add
a cup of green tea to complete the scene.

Shrimp Tempura

Outline the fried shrimp with an undulating line, to suggest the fluffy, crispy texture of the batter.

Fill with rounded, golden yellow brushstrokes.

The shrimp's tail adds a colorful accent.

Variation

Pile a rice bowl high with fried shrimp and vegetables to make tempura don.

Chilled Tofu

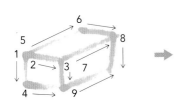

Draw a three-dimensional rectangle.

Bonito flakes

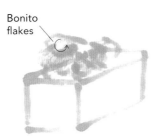

Draw the wispy bonito flakes with the side of your brush pen just barely touching the paper.

Variation

In Japan, tofu is often accompanied by a dish of soy sauce.

ANIMALS

The key to drawing living creatures is to emphasize motion and expression. Let's start out with some familiar animals you might see in everyday life.

Dogs

Dogs come in all shapes and sizes, but we'll start off with some simple pooches with perked up ears. Let's begin with the face, and then try a full figure.

Face

Start with an oval for the nose.

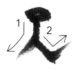

Add a V shape for the mouth.

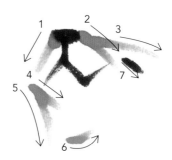

Use quick lines to draw the snout and chin. Add a slanted eye for a gentle expression.

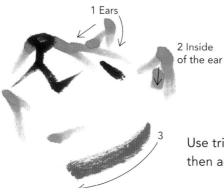

Use triangles for perked ears, and then add a curved collar at the neck.

Body

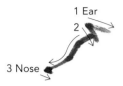

Outline the face, including an ear and the nose.

Tip

Draw the back with a single line that slopes downward.

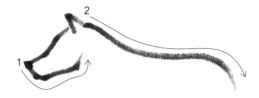

Add the chin and back.

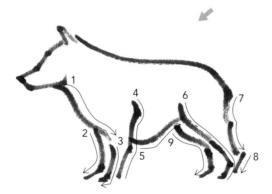

Draw the body and legs.

Tip

To create leg joints, stop and change direction as you draw the overall leg.

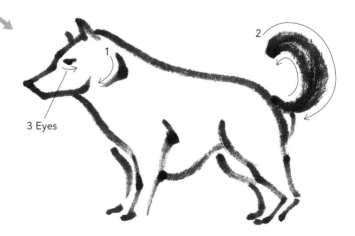

Add a curved tail for a friendly touch.

Chow Chow

Draw a rounded triangle.

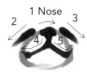

Use black to add the
eyes, nose, and mouth.

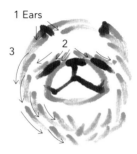

Draw the fur in short strokes
that curve down and around
the face, to give your Chow
Chow a soft, fluffy look.

Golden Retriever

Start with an oval
for the nose.

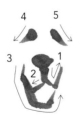

Add the eyes,
and mouth.

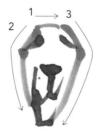

Use angular lines to
outline the face.

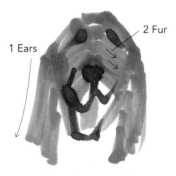

Use long lines to draw
floppy ears. Fill in the
face with diagonal lines
extending from the center.

Dachshund

Start with the ear.

Add the face and back.

Tip

When you fill in the body, use the side of your brush for a bold, wide line.

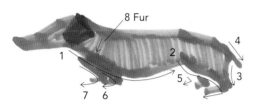

This breed is known for its long face and torso, combined with cute little legs.

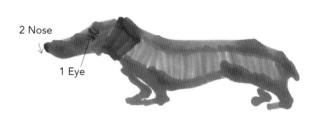

Add the finishing touches.

Poodle

Angle your brush tip against the paper, and then make a brisk upward stroke to create the face.

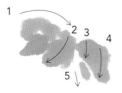

You don't need to draw an outline for this one! Use big swipes of the pen to draw puffs of hair.

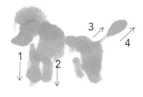

Add the legs and tail.

Cats

Cats are easy to recognize with just a few lines to suggest their slanted eyes and pointed ears. Let's start with some basic cats before we move on to common cat activities.

Face

 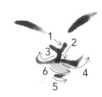 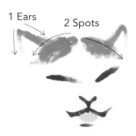

Draw slanted black lines for the eyes.

The eyes, ears, and mouth are drawn with quick brushstrokes to give this cat an expression full of personality.

Frame the face with triangular ears, and then add a few spots to the forehead.

Head

Draw slanted black lines for the eyes and a flat oval for the nose.

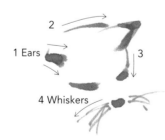

Draw triangular ears and a small curve to suggest the shape of the head. Long whiskers accent the nose.

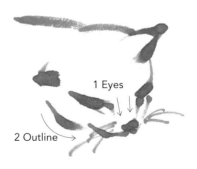

Use rough lines to frame the face and suggest the texture of the cat's fur.

Full Body

Start with two spots separated by a patch of white fur.

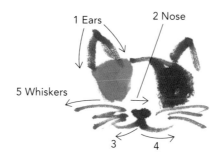

Add the ears, nose, mouth, and whiskers.

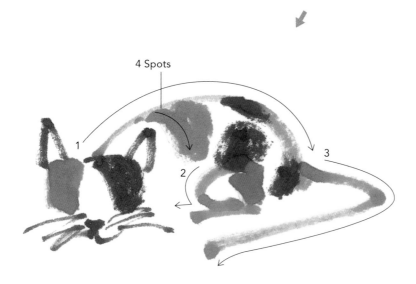

When drawing the spots, show how they wrap around the cat's body by changing the pressure and angle of your brushstrokes.

Yawning

Use a flicked dot
for the nose.

Draw a long mouth
beneath the nose.

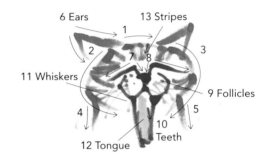

A wide-open mouth and
droopy eyes are the keys
to capturing a yawn.

Grooming

Start with the paw.

Add the eyes and nose
just above the paw.

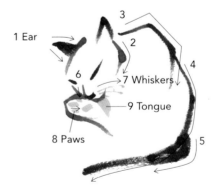

Apply firm pressure as you draw
thicker lines for the base of the
tail. Add pink dots for the paw
pads and the tongue last.

Sitting

1

Draw the nose and mouth.

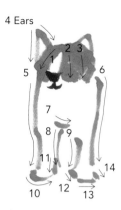

4 Ears

2 3
1
5
6
7
8 9
11
10 12 13
14

First, outline of the cat's face and ears. Next, draw the chest and front legs beneath the head.

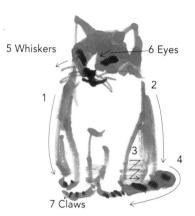

5 Whiskers
6 Eyes
1
2
3
4
7 Claws

Fill in the body with rounded back legs and a tail. Add some tiny dark claws to the feet and stripes to the tail.

Stretching

Draw an open oval for the head.

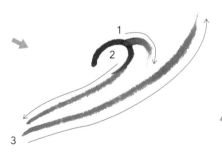

1
2
3

Add a small curve for the shoulders, then draw two long, sweeping lines for the front legs.

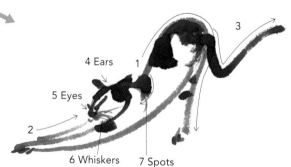

4 Ears
1
3
5 Eyes
2
6 Whiskers
7 Spots

Draw a dramatically arched back and straight hind leg, then finish with a bent tail. Use expressive lines to capture the motion of this pose.

Various Animals

Now let's draw some wild animals you might see at a zoo, an aquarium, or maybe even as you're walking down the street! Choosing the right body angle or facial expression can really bring your illustration to life.

Bear

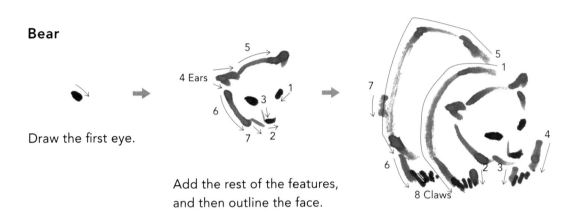

Draw the first eye.

Add the rest of the features, and then outline the face.

Use thick curves to draw the shoulders, front legs, and back. Add some quick strokes for claws.

Rabbit

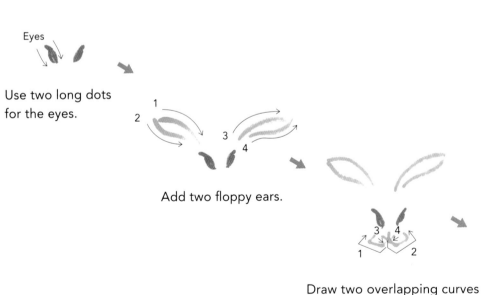

Eyes

Use two long dots for the eyes.

Add two floppy ears.

Draw two overlapping curves for the cheeks and nose.

Use round curves for the legs and body.

Sheep

Use a flicked dot for the nose.

Add two slanted ovals for the eyes.

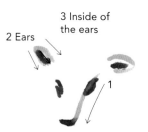

3 Inside of the ears

2 Ears

1

Draw a slanted line for the muzzle, and then add the ears.

Wool

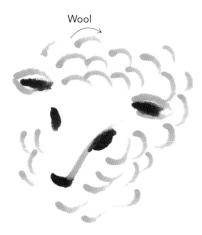

Draw the sheep's wooly coat with quick, curved strokes of the pen.

Alpaca

1 2

Draw an oval-shaped face.

4 5
1
2
3

Use a darker shade of brown to add the eyes, nose, and mouth.

1 Ears

2
Fleece

3 Feet

Draw the alpaca's fleecy coat with quick, rhythmic strokes of the pen.

Giraffe

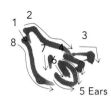

Giraffes spend a lot of time eating leaves, so draw an upturned head.

Use long lines for the graceful neck.

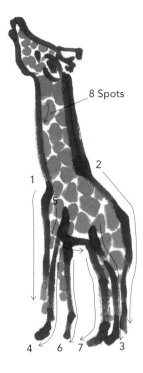

8 Spots

As you draw the giraffe's patterned fur, randomly alternate between round dots and long dots.

Panda

Draw the first eye.

1
2

Add the other eye and a flicked dot for the nose.

1
2

Add two more black ovals for the ears. Just a few dots can make a very cute panda!

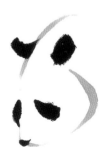

Variation

Try adding a light outline—drawing the panda in three-quarter view can add some realism.

Chipmunk

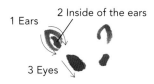

1 Ears
2 Inside of the ears
3 Eyes

Use oval shapes for
the eyes and ears.

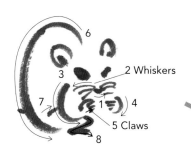

6
3
2 Whiskers
7
1
4
5 Claws
8

Use big curves for the
back and arms.

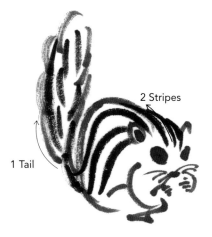

2 Stripes
1 Tail

Draw a thick, fluffy tail, and then add
a chipmunk's characteristic stripes.

Koala

Start with the nose.

Eyes →

Add two slanted eyes.

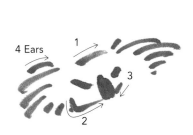

4 Ears
1
3
2

Use quick lines to outline
the face with fur.

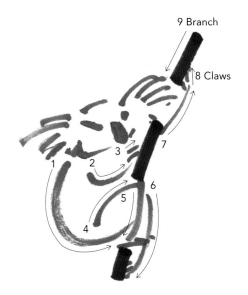

9 Branch
8 Claws
1
2
3
7
5
6
4

For a koala hugging a tree branch,
draw the body in one quick swoop
using the side of the brush.

Zebra

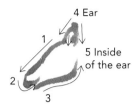

Outline the head.

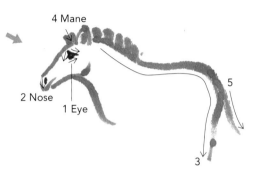

Add the chest, back, and mane.

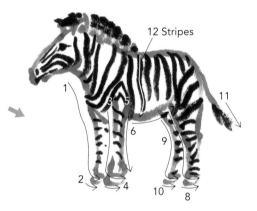

A zebra's stripes wrap around its body, so vary your line weight as you draw them.

Camel

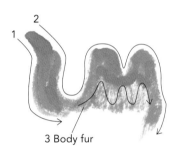

Draw a long neck and a gently curved M for the humps.

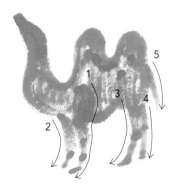

Add the legs and a rounded tummy.

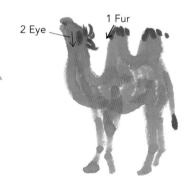

Draw a large eye and add some fur.

Tip
Draw the thick upper legs with the side of your brush.
Then ease up on the pressure as you move down the leg,
drawing the foot with the very tip of your brush.

Boar

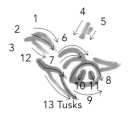

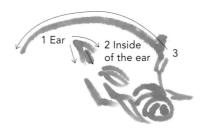

Start with the eyes, and then draw the snout and tusks.

1 Ear 2 Inside of the ear 3

Add the ears and curved back.

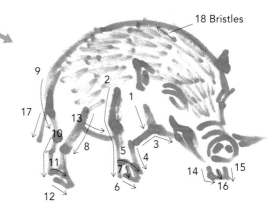

18 Bristles

For the bristles, lightly drag your brush tip down the boar's back several times, from head to haunch.

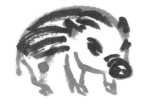

Variation

Add stripes to transform the illustration into a wild boar piglet.

Pig

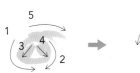

Use curved lines to draw the snout.

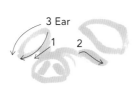

3 Ear 1 2

Add the ears.

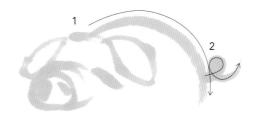

1 2

Taper your lines from thick to thin for a realistically rounded pig.

Peacock

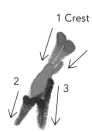

Start with a
teardrop shape.

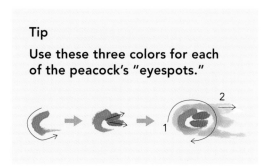

Use the very tip of your
brush to draw the crest, and
then add quick strokes for
beak and neck below.

1 Crest

2

3

1

2 3

4 Leg

For the body, use the
side of your brush.
Apply pressure at the
beginning and end of
each brushstroke.

Tip

**Use these three colors for each
of the peacock's "eyespots."**

1

2

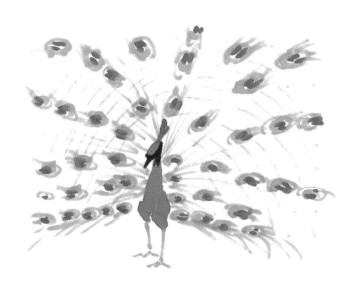

Peacocks have gorgeously patterned plumage.
Increase the size of their "eyespots" as you move
out from the body to the edge of their feathers.

Chicks

 1

Make a circle
for the head.

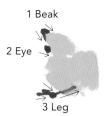 **3**
2
1

Use three
brushstrokes to
make the body.

1 Beak
2 Eye
3 Leg

Use dark brown
to add details.

Tip

**Use the side of your brush in
short, overlapping brushstrokes
for the head and body.**

Variation

When drawing a group, try to draw
your chicks from all different angles.
This means their heads and beaks
will be facing different directions.

Duck

 1

Start with a
curved cheek.

 1
2

Use two
brushstrokes to
make the beak.

Tip

**Apply some extra pressure when
drawing the base of the beak to
make it look more realistic.**

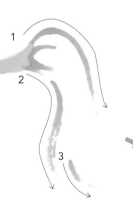 **1**
2
3

Use gentle curves
to create the head
and neck.

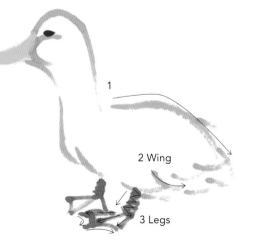 **1**
2 Wing
3 Legs

Use wispy curves to draw the
body and wings. Use zigzags
for the webbed feet.

Mallard Duck

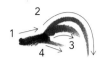

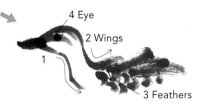

Draw a straight line for the beak, and then add a curved line for the head.

Ducks have unique feather patterns. If you're drawing a swimming duck, don't worry about including the legs, since the water would hide them.

Tip

Use the side of the brush to draw the beak in one quick stroke.

Variation

Ducklings usually have yellow faces. They look absolutely adorable following after their mother!

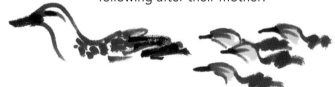

Rooster

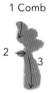

Use ovals to make the comb and wattle.

1 Comb

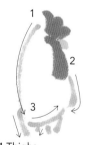

4 Thighs

Draw an oval body, and then add slanted lines for the thighs.

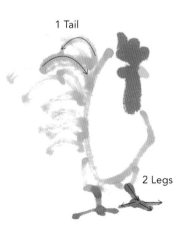

1 Tail

2 Legs

To give your rooster long, fluffy tail feathers, draw rough, quick curves with the side of your brush pen.

Japanese Bush Warbler

Start with a long
flicked dot.

Add a smaller flicked
dot, followed by an
angular line.

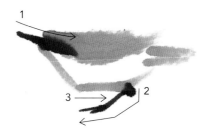

Draw the dark beak and eye
together with a single, straight
brushstroke. Use the tip of the
brush to draw the thin leg.

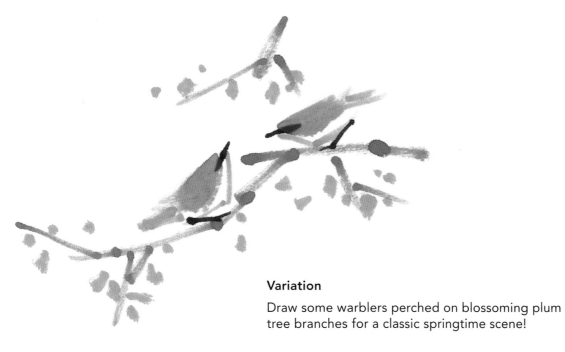

Variation

Draw some warblers perched on blossoming plum
tree branches for a classic springtime scene!

Sparrow

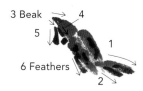

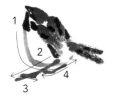

Use three rough strokes to sketch the head and body.

Add black markings around the eye, cheek, and throat for classic sparrow coloring.

Add a rounded tummy and thin little legs.

Variation

When viewed from the front, this songbird looks like it's wearing a tiny beret!

Bat

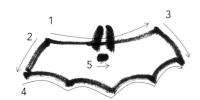

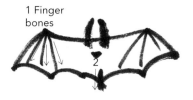

Start with two small triangles for the ears.

Draw a trapezoid with a scalloped bottom edge to complete the bat's body.

The bones inside a bat's wings are actually fingers! Add the finger bones and a tail.

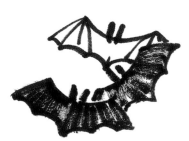

Variation

When drawing a group of bats in flight, use rough black brushstrokes to color some of the bodies.

Crane

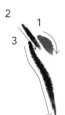

Draw the beak and eye together with a single stroke.

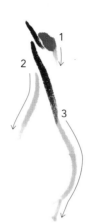

You only need black, grey, and a little red for this crane. Draw the elegant shape of its body with gentle, curving lines.

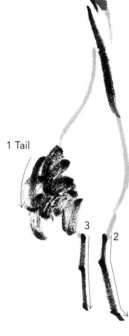

1 Tail

Use rough brushstrokes for the tail feathers and long legs.

Variation

Try drawing a crane flying with outspread wings. When drawing its skinny legs, pause partway through to leave dots of ink suggesting the knee joints.

Tip

Cranes are known for their elegance. Use the tip of the brush to make thin, graceful lines when drawing this beautiful bird.

Seagulls

Start with an arched curve.

Add a diagonal line for the body and another arched curve for the second wing.

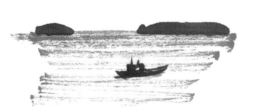

Tip

You can change the direction of your flying seagulls by changing the angle of their wings.

Start with a slightly diagonal line.

Add a vertical diagonal line to complete the V shape, lifting your brush at the end to create a tapered effect.

Start with a downward diagonal line.

Add an arched curve to create the wide V shape.

Variation

Add some simple horizontal lines for the ocean and an island or two, and you have a landscape painting!

Dolphin

Draw a short horizontal line for the beak.

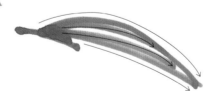

Use gentle curves for the back. To depict a dolphin's smooth, streamlined form, draw each line in a single stroke, moving from the tip of the beak to the tail.

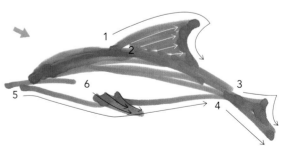

Add the fins, tail, and underside of the body.

Seal

Start with a rounded head.

Use thick curves to capture the roundness of the seal's body.

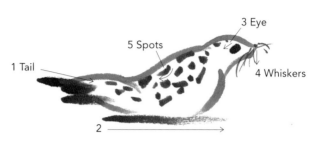

5 Spots

3 Eye

1 Tail

4 Whiskers

2

For a spotted seal, add dots to the back.

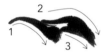

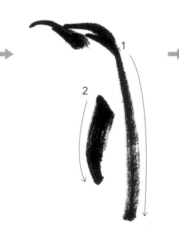

Variation

A pair of cuddling seals makes for a cute scene.

Penguin

Use three curves to complete the beak and head. Leave a bit of white space on the face.

For a sturdy, well-balanced penguin, draw the back in a single line that starts from the head and widens at the bottom.

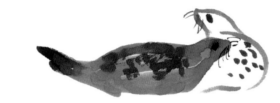

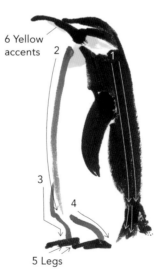

6 Yellow accents

2

1

3

4

5 Legs

For a standing penguin, make sure the chest curves outward. A yellow beak and feathers serve as colorful accents.

Squid

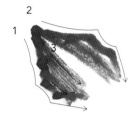

Draw a leaf-shaped head.
Fill the edges with color,
leaving the center blank.

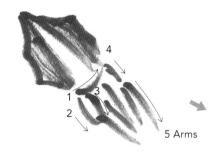

Hold your brush straight up
and down, and draw with
fast strokes. This will make
your squid look like it's
shooting through the water.

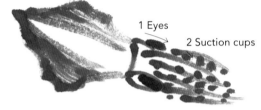

Add the details, including the
squid's large eyes and suction
cups on the arms.

Octopus

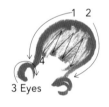

Draw a domed
head and two large,
protruding eyes.

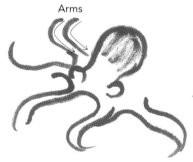

Use wavy lines to draw long,
undulating arms.

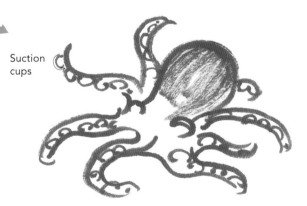

Add circular suction cups to the arms.

Crab

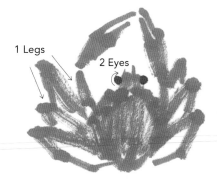

Draw a rough hexagon for the body. Add a small face at the top.

Draw large claws extending upward.

Draw three long legs on each side of the body. The legs should taper to a point.

Variation

Use more muted colors for freshwater crabs.

Shrimp

To draw the shrimp's long, triangular head, place the very tip of your brush pen on the paper. Press down firmly and make a short, quick brushstroke.

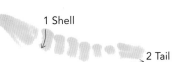

Use small curves to draw the long, narrow abdomen.

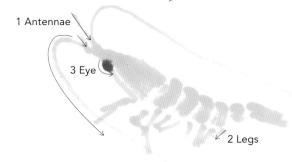

Do not use parallel lines for the legs—make sure they extend in different directions in order to create movement.

Variation

Give your shrimp a slim body and long arms to turn it into a freshwater prawn.

Variation

Add bigger claws for a lobster.

Sea Bream

Use a series of short lines to create the mouth, and then draw a large curve for the body.

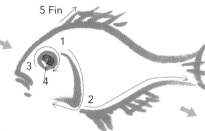

For the pointed fins, make quick, slashing brushstrokes with the tip of your pen.

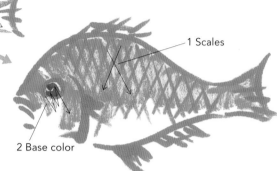

1 Scales

2 Base color

Combine red and orange to capture the vivid coloring of this fish. Tilt your brush at an angle and move it quickly over the paper for a rough, scaly texture.

Koi

Make two quick lines for the mouth, and then add two curved nostrils.

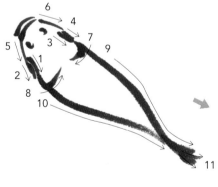

Complete the outline of the head, body, and tail. Use gentle curves to capture the elegant motion of this fish.

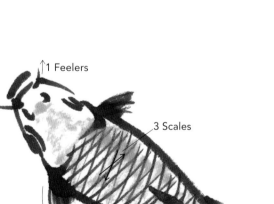

1 Feelers

3 Scales

2 Fins

Use rough lines to add the fins, and then use the tip of the brush to create a scaly texture.

Tip

For the gills (7-8), make your brushstrokes swoop in from the outline of the body.

Goldfish

Body

For the body, draw three short lines with the side of your brush. Try to suggest some volume with their shape.

1 Tail fin

2

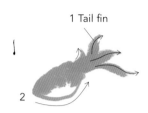

Tilt your brush as you draw, and lift it from the paper to make the tail's long, tapered points.

1
4 3
2

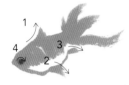

A rounded tummy is very cute!

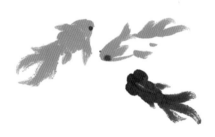

Variation

For an interesting scene, draw an assortment of goldfish breeds swimming together. Try adding a globe-eyed black goldfish.

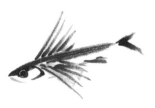

Japanese Rice Fish

Start with a light
horizontal line.

Add a darker long dot on
top of the horizontal line.

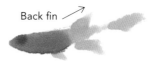

These little fish only
need dots for eyes.
Use dark-to-light
shading to give the
body some dimension.

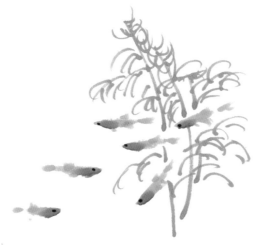

Variation

Add a sea plant to complete
the underwater scene.

Sea Snail

Start with two
graduated
circles for the
tip of the shell.

Continue adding curves to
complete the spiral shape. Make
sure to leave a bit of uncolored
space between each twist.

Use a lighter shade to
fill the shell, completing
the snail's body.

Clam

Start with an inverted V.

Use two curves to complete the shell.

Use the side of your brush to draw the rough surface of the shell.

— Striped pattern

Turban Shell

Sketch a pointed circle, then shade the center of the circle dark.

Add the next layer of the shell, including a few spines.

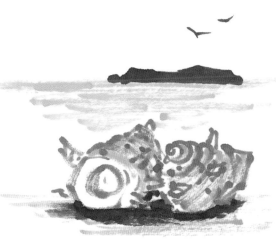

Variation

Add a simple ocean background to transform your drawing into a landscape painting!

Taper the shell into a point. Make sure to draw spines protruding from every curve.

Frog

Start with a long triangle for the head and body.

Use short lines to add bent legs and webbed feet.

Eyes

Try to minimize the number of brushstrokes you use—keep things simple for this cute seated pose.

Variation

Ribbit! Draw a puffy throat for a frog making noise.

Variation

Spread the arms and legs wide to capture a frog mid-jump.

Turtle

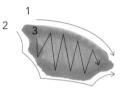

Draw a gradual curve for the upper edge of the shell and an angular line for the lower edge.

Shell pattern

Use a darker shade of brown to create a rectangular shell pattern.

1

3 Eye

2 Flipper

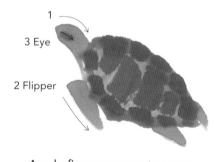

Apply firm pressure to your pen as you begin drawing the flippers, then gradually ease up to create the tapered tips.

Variation

To draw a tortoise, make a high, dome-shaped shell and thick legs.

Snail

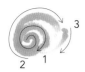

Draw a spiral
for the shell.

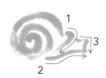

Draw the head extending
from the shell.

Tip
It's difficult to draw a spiral in one stroke,
so try using 2-3 connected lines instead.

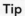

Add long antennae, and
then decorate the shell
with a striped pattern.

Ladybug

Draw a short
horizontal
line, and then
add a flat oval
underneath.

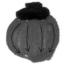

Use curved
brushstrokes
to create a
circular body.

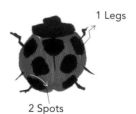

Use the tip of the
brush to add tiny
legs. Don't forget
the spots!

Butterfly

Start with a quick brushstroke for the body.

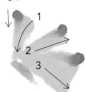

4 Wing pattern

To draw the wings closest to the viewer, begin by placing tip of your brush next to the butterfly's body. Then draw outward while increasing pressure on your pen and widening your brushstrokes.

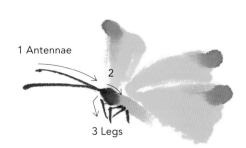

1 Antennae

2

3 Legs

Draw two long antennae, a head, and thin legs.

Tip

Add a flicked dot of ink to the tip of each wing for a pop of extra color.

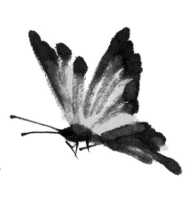

Variation

You can also create elegant wing patterns by alternating black stripes with blue or yellow.

Rhinoceros Beetle

Draw a slanted
T shape for the horn.

Use the side of your
brush to draw gentle
curves for the head.

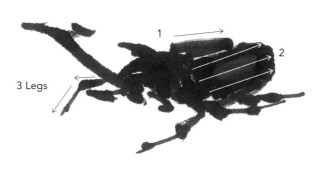

3 Legs

You can suggest joints by drawing
the legs in rough segments.

Stag Beetle

Draw two rectangles
for the head.

The stag beetle has a flat
head and body, so break
them up into four sections
separated by white.

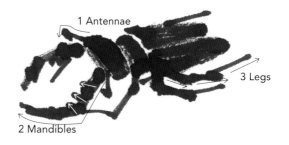

1 Antennae

3 Legs

2 Mandibles

Add short lines to the inside of the
mandibles to give them a toothy look.

Dragonfly

Draw two green curves, and then fill the center with a neutral shade.

Body

Use short black brushstrokes to create a long, thin body.

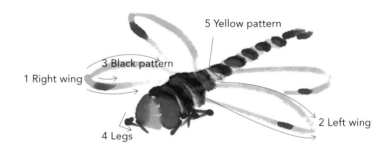

5 Yellow pattern

3 Black pattern

1 Right wing

2 Left wing

4 Legs

For a touch of realism, add black dots to the front edges of the wings, right before the tips.

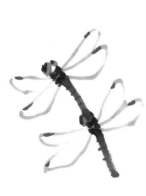

Variation

By changing the color of the body, eyes, and wings, you can draw different types of insects, like scarlet and river dragonflies.

Cicada

Draw four
horizontal lines.

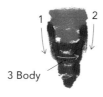

1
2
3 Body

Use the side of your brush
and make several small
strokes for the body.

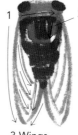

1
2 Spotted pattern
3 Wings

Move your brush quickly as
you draw the delicate wings,
making sure your lines are
thin and lightly drawn.

Mantis

1
2

Use two strokes
to create a heart-
shaped face.

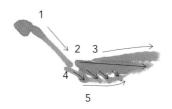

1
2 3
4
5

Use the tip of the brush
to draw the long neck and
body using a series of lines.

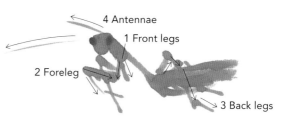

4 Antennae
1 Front legs
2 Foreleg
3 Back legs

Use rough brushstrokes to show
the sharp edges of the foreleg.

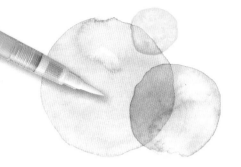

WATER BRUSH PEN TECHNIQUES

Now that you've mastered the brush pen basics, let's learn how using a water brush pen can transform simple marker drawings into watercolor-inspired works of art. The following guide provides tips and tricks for using a water brush pen on different types of drawings.

Eggplant (page 20)

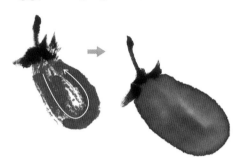

Follow the shape of the eggplant with the brush tip.

This creates a shiny effect characteristic of an eggplant's skin.

Potato (page 22)

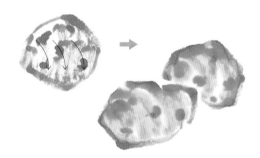

Use the side of the brush to paint curved lines.

This gives the potato a round shape and creates multiple shades of brown.

Corn (page 20)

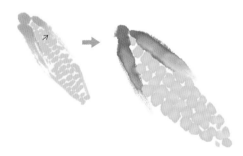

Apply the brush tip to each kernel of corn.

Once the illustration dries, the kernels will have a plump, three-dimensional appearance.

Napa Cabbage (page 25)

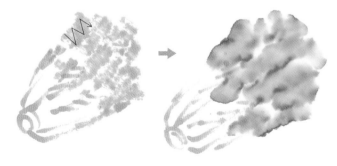

Use the side of the brush to draw a zigzag pattern over the green leaves.

This gives the leaves a voluminous appearance.

Grapes (page 14)

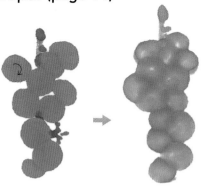

Use brush tip to lightly add a drop of water to each grape.

Move the drop of water to center or side to create highlights depending on the grape's position within the bunch.

Pineapple (page 30)

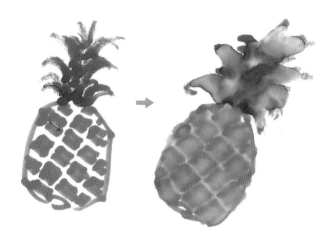

Use the side of the brush on the pineapple's body. For the leaves, use the brush tip and work up from the bottom to the top.

The wet brush strokes create a voluminous effect on the leaves and emphasize the checkered pattern of the pineapple's skin.

Pear (page 29)

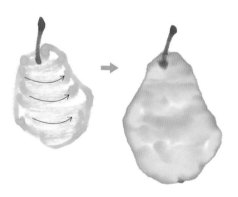

Move the brush tip sideways, following the curve of the fruit.

The water creates a realistic texture on the pear's skin and incorporates multiple shades of color.

Cherries (page 27)

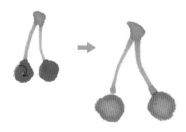

Apply the brush tip to the center of each cherry.

The water adds shine and dimension.

Sweet Buns (page 39)

Use the side of your brush to draw a circle on the bun.

The water will lighten the color of the buns, making them look even more plump, soft, and delicious.

Mitarashi Dango (page 37)

Use the side of your brush to draw an arc on each dumpling.

This blending effect amplifies the soft texture and round shape of the dumplings.

Macarons (page 33)

Follow the shapes of the macaron cookies with the tip of your brush.

This will give the cookies a smooth, shiny look.

Shrimp Tempura (page 43)

Apply short brushstrokes in a random pattern across the fried shrimp.

This will make the batter look thick and fluffy, as if it's just come out of the fryer!

Rhinoceros Beetle (page 75)

Use the side of your brush to trace around the head and down the wings.

This will give the beetle's carapace a glossy, rounded sheen.

Dachshund (page 47)

Use the side of your brush on the body and face, avoiding the ears.

The water brush pen softens the angles of the dog's body and can add some gentleness to its expression.

Shrimp (page 67)

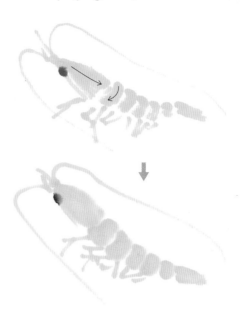

Trace each individual section of the shrimp with the side of your brush.

This adds volume and dimension to the crustacean's segmented body.

Chick (page 59)

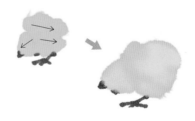

Add thick brushstrokes with the side of your pen.

This will emphasize the fluffiness of the chick's downy feathers for an extremely cute effect!

PLANTS

Brush pens are perfect for sketching elegant floral designs. Use different line and coloring techniques to capture the various textures of the petals, leaves, and stems.

Lily

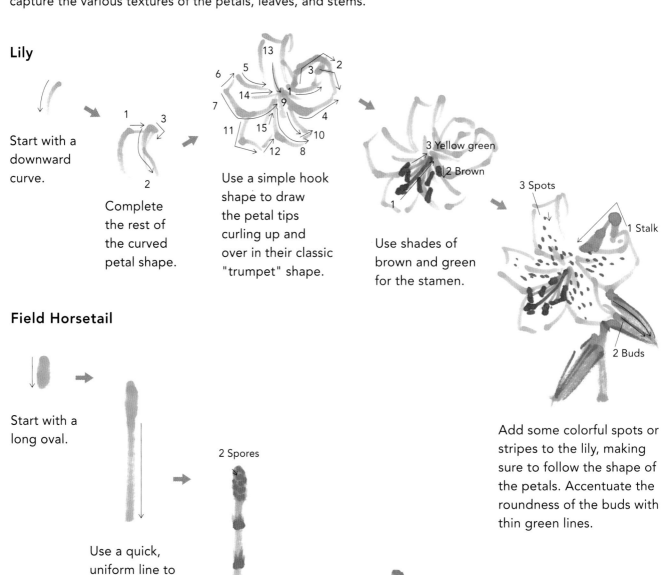

Start with a downward curve.

Complete the rest of the curved petal shape.

Use a simple hook shape to draw the petal tips curling up and over in their classic "trumpet" shape.

Use shades of brown and green for the stamen.

3 Yellow green

2 Brown

1

3 Spots

1 Stalk

2 Buds

Add some colorful spots or stripes to the lily, making sure to follow the shape of the petals. Accentuate the roundness of the buds with thin green lines.

Field Horsetail

Start with a long oval.

Use a quick, uniform line to create the stalk.

2 Spores

1 Sheaths

Draw the dark sheaths on the stem in two or three short strokes, moving upward.

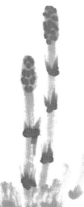

Tip

Draw the spores with dots, moving from the outside toward the center.

Variation

When drawing multiple horsetails, use different heights for the stalks to create depth.

Camellia

1
2

Draw the
two foremost
petals in a
wide V shape.

Stamens

Draw the central
stamens clustered
tightly together.

3 4
1
2

Fill in the remaining petals
to complete the flower.

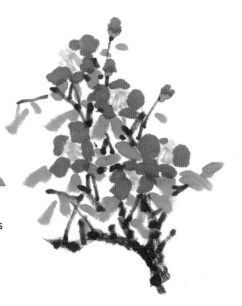

Plum Blossom

Start with a
quick circle.

2
1

Add ovals on
each side.

2
1

Add another
layer of petals.

Use simple dots and short
brushstrokes for the leaves.

2
1 **3**

The plum blossom's calyx
(those short leaves at the
base of the blossom) is
shaped like the Japanese
character for "small"!

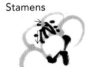

Stamens

Use the tip of your
brush to add lines and
dots for the stamens.

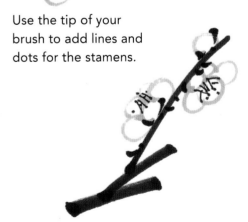

Plum blossoms are often pink.
This white variation gives your
illustration a peaceful feeling.

Dandelion

Draw the dandelion's tiny petals radiating out from a center point. Make each one a long, thin oval.

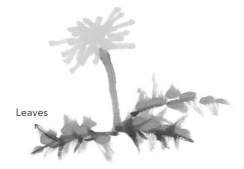

Use a slightly curved line for the thin stem.

Leaves

For the leaves, use the side of your brush in fast, short strokes. These rough brushstrokes mimic the "toothed" edges of the leaves.

Japanese Iris

Draw the two foremost petals in a V shape, starting from the outside and working toward the center.

The petals are very narrow at the center, but widen dramatically at the tips.

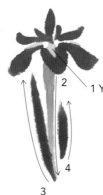

1 Yellow pattern

Add yellow to the center of the flower. Use quick brushstrokes for the stem and leaves.

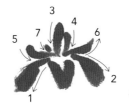

Create a sharp impression by drawing the leaves with long, fast brushstrokes.

Carnation

Petals

Start out by drawing the petals very roughly using the side of your brush.

Outline

Go back and outline the petals.

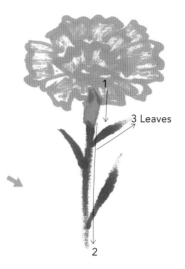

1
3 Leaves
2

Carnations are the perfect motif for Mother's Day cards!

Tulip

Start with a long oval.

3 4
1 2

Add two more ovals for petals. Next, draw two round dots for the back petals.

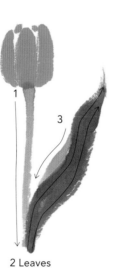

1
3
2 Leaves

Give the leaves some motion with sinuous brushstrokes. Add some lighter color to the top for extra volume.

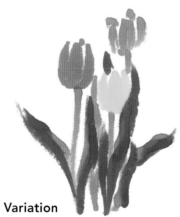

Variation

Tulips grow in nearly every color of the rainbow. Try drawing an assortment of brightly colored tulips.

Wisteria

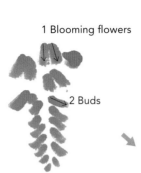

Draw the first two petals in an inverted V shape, starting from the top.

Draw the blossoms at the top of the hanging cluster with brush-strokes that angle downward. The lower buds point outward instead.

1 Blooming flowers

2 Buds

2 Flower petals

1 Stem

Add a stem running through the center, and then accent the petals with a second shade of purple.

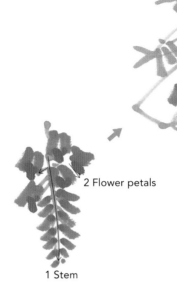

Using two different colors for the petals creates shadows. The vines can be drawn with quick brushstrokes.

Sunflower

Draw a brown circle for the center of the flower.

Seeds

Add lighter dots for the seeds.

Petals

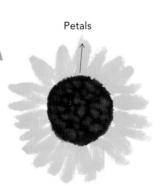

Draw each petal with a slightly different length for a realistic look.

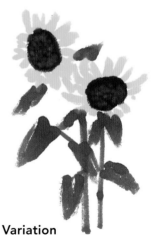

Variation

Add leaves and tall stalks to make a field of sunflowers.

Morning Glory

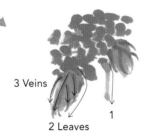

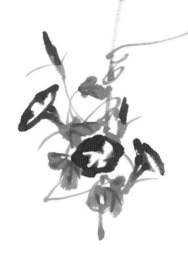

Start with a swooping curve.

Use three small curves to complete the circular shape of the flower.

Add the tubular portion of the flower and the stem.

Draw the morning glory blossoms from several different angles.

Hydrangea

Start with a few oval dots.

2 Green

1 Purple

Hydrangeas bloom in clusters of small flowers. Use oval dots for the petals, starting at a central point and moving outward.

3 Veins

2 Leaves

1

Use the side of your brush for leaves, drawing them from top to bottom in 1-2 brushstrokes. Then, use the tip of your brush to add veins in a darker color.

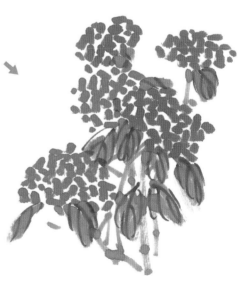

Hydrangeas range from brilliant blues and purples to soft shades of white.

ASIAN ART

Brush pens originated in Asia, so they are well suited to drawing traditional Japanese motifs. Let's try a few illustrations celebrating Japanese culture.

Japanese Fan

Draw ¾ of a circle.

Draw the handle with the side of your brush, in a single, strong stroke.

2 Leaves

1 Flowers

Decorate the fan—A classic Japanese motif, like these morning glories, can add a simple and tasteful accent to your illustration. See page 87 for morning glory instructions.

Cherry Blossom

Blooming Flower

Draw the two foremost petals in a V shape, starting from the outside and working toward the center.

For the remaining petals, start at the center of the flower and work outward.

3 Stamens

Add a stem and stamens to complete the blooming flower.

In Japan, cherry blossoms represent the fragility and beauty of life.

Bud

Draw the two petals in an inverted V shape, starting from the top.

Add a stem to complete the bud.

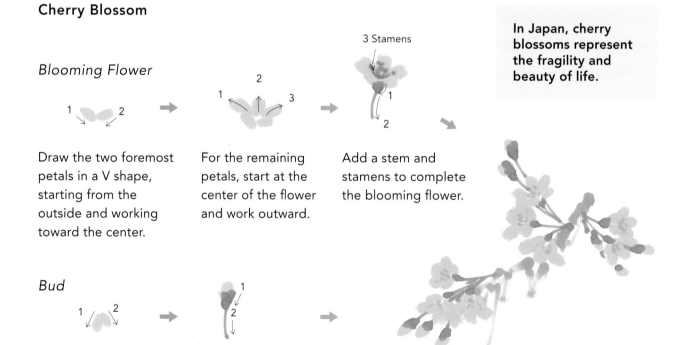

Cherry blossoms often bloom in clusters. Try to create a balanced arrangement of buds and flowers together on a branch.

Hina Dolls

Start with a flicked dot.

Add a long, narrow face and a horizontal line.

Draw their voluminous kimonos with simple geometric shapes (squares, triangles, trapezoids, and semicircles).

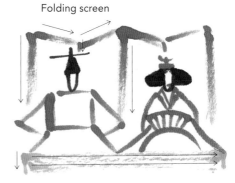

Folding screen

Celebrate the Doll Festival with these ornamental Emperor and Empress hina dolls. Add a golden folding screen behind your dolls for a traditional altar display.

Start with a U-shaped curve.

Add the red and black details.

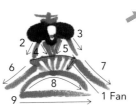

1 Fan

Carp Windsock

Draw three curves to create the open mouth.

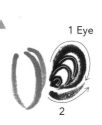

1 Eye

Draw a series of arches for the eye.

Add a nice smooth curve for the head and body.

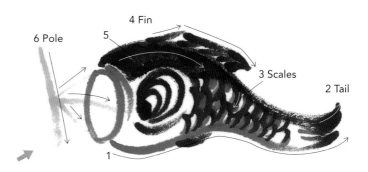

6 Pole

4 Fin

5

3 Scales

2 Tail

1

These colorful cloth streamers flutter in the sky for Children's Day. Draw the fish's body quickly with curving brushstrokes to give it some movement in the breeze.

BLACK & WHITE ILLUSTRATIONS

Although today's pens are available in hundreds of different shades, brush pen illustration was traditionally done in black ink. Black ink is an ideal choice for Asian-inspired drawings, such as the zodiac signs, and scenes from nature, but can also lend a touch of elegance to everyday objects.

Zodiac Signs

The twelve Chinese zodiac signs make excellent subjects for brush pen illustrations. These stylized images are fun to draw with brush pens!

Rat

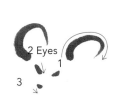

Use sweeping curves for the ears.

Draw the eyes pointing down at an angle.

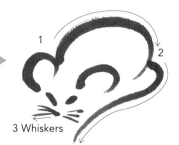

You only need a couple of soft open ovals to draw this simple rat. A long, tapering tail and some whiskers complete the illustration.

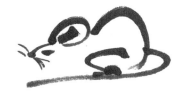

Variation

For a rat viewed in profile, use a quick, light line to draw the hindquarters, which extend higher than the head.

Ox

Use a gradual swooping curve to represent the horns. Just make sure both ends are pointed.

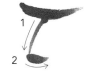

Add the muzzle and a long dot for the nose.

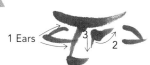

Add the ears, and then make a flicked dot for the eye.

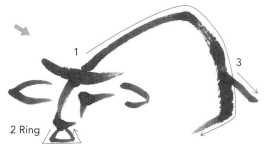

Use a strong, curved brushstroke to outline the substantial body.

Tiger

Start with a bean shape
for the open mouth.

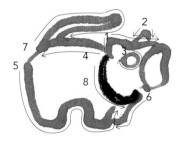

This stylized tiger was inspired by
a traditional Japanese akabeko
toy. Use big, soft brushstrokes to
give the tiger a rounded shape.

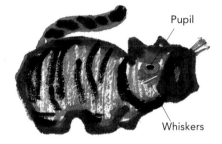

Color in the fur with rough
brushstrokes, and then add
some stripes on top.

Rabbit

Start with a long,
floppy oval for the ear.

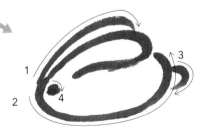

Use thick, curving brushstrokes to
capture the rabbit's round, fluffy shape.

Dragon

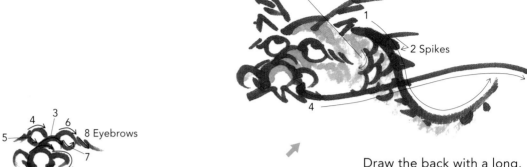

3 Scales

1

2 Spikes

4

Use two connected semicircles for the tip of the dragon's nose.

4
3
5
6
8 Eyebrows
2
7
1

Add another semicircle to complete the nose. Use a series of small curves for the ridged snout and the big, round eyes.

2 Horns

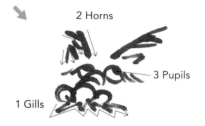

3 Pupils

1 Gills

Use angular lines for the large horns, ears, and gills.

Draw the back with a long, bold, and flowing line. Give your dragon dramatic whiskers, and then go back in with a lighter gray to add texture to the scales.

Snake

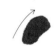

Start with a small oval for the head.

3 Eyes

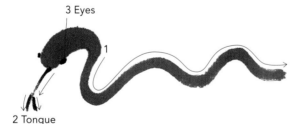

1

2 Tongue

Use a single wavy brushstroke for the body. Use quick lines to add the eyes and forked tongue.

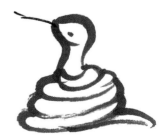

Variation

Try drawing a coiled snake. Use quick brushstrokes that are lighter in the middle to help add volume.

Horse

Draw a large, loose M shape, with one side slightly diagonal. This will be the horse's neck.

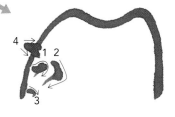

Add a few simple lines to suggest the ears, jaw, and facial features.

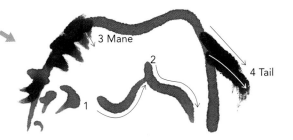

Finish the horse's body by adding some gently curving lines for the stomach and hind leg. Use thick brushstrokes for the tail.

Variation

A profile view of a horse's head makes for a stylish illustration. Use two connected flicked dots for the eye to give your horse a gentle expression.

Sheep

Combine a line and a curve to draw the eye.

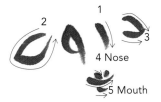

Draw the sheep's ears using two curving brushstrokes, with the top curve slightly straighter than the bottom.

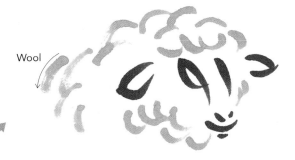

Move your brush in rhythmic semicircles to create round tufts of wool for the sheep's fleece.

Monkey

You can draw a Japanese macaque's face with only a few straight lines! Start with a thick, horizontal brushstroke for the brow.

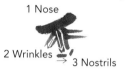

1 Nose

2 Wrinkles **3 Nostrils**

Add two vertical lines for the bridge of the nose. Next, add wrinkles around the monkey's muzzle using two diagonal lines on either side of the nose. Finally, add two short, diagonal lines for nostrils.

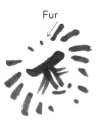

Fur

Use radiating diagonal lines for the fur surrounding the face.

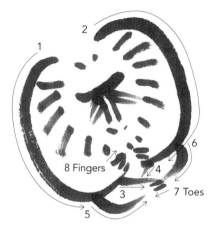

Use large parenthesis-shaped curves to outline the face and body. Finish the illustration with a few short lines for hands and feet.

Rooster

Start with a C shape for the chest.

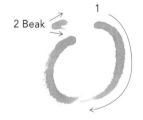

2 Beak **1**

Add another curved line to complete the body, leaving space at the top for the head. Add a small triangle for the beak.

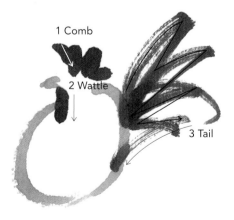

1 Comb

2 Wattle

3 Tail

Draw the tail with the side of your brush, using dynamic zigzagging brushstrokes. Use a darker shade for the comb, wattle, and tail to make these features pop.

Dog

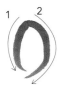

Start with a tall oval for the snout.

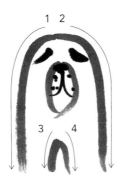

Use slanted lines for the eyes, and then add the rest of the facial features.

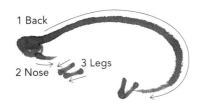

A head-on, seated pose is always quite charming! Use one big upside down U shape for the body.

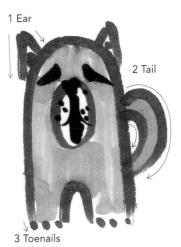

Add a pair of pointy ears, a curled up tail, and a big, friendly tongue. Color in the fur if desired.

Pig

Start with a slanted oval for the tip of the snout.

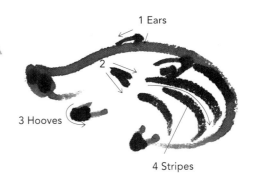

Use one big swoop of your pen for the body, starting from the tip of the nose and extending all the way around the bottom.

This design features a wild boar piglet with a uniquely striped coat. When drawing the stripes, make quick, curving brushstrokes to create a furry texture.

Nature

When working in black ink, remember to keep your shapes and lines simple. Use different shades of ink to add details such as leaf veins and flower petals.

Maple Leaf

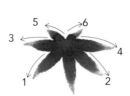

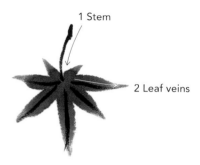

Start by firmly pressing your brush tip to the page, and then move your pen down in a vertical brushstroke, lifting it from the page for the leaf tip.

As you work, try rotating your paper to make each leaf point easier to draw.

Use darker ink to draw the stem and leaf veins.

Acorn

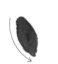

Apply firm pressure at the beginning of your brushstroke, and then loosen your grip as you reach the end.

Use two strokes to draw a round acorn cap with a short stem.

Variation

Chestnuts grow inside prickly burrs. Use thin lines to create the spiky casing.

Chestnut

Starting at the tip of the chestnut, draw two thick brushstrokes with an inverted V shape.

Using the side of your brush tip, roughly fill in the chestnut's outline with zigzagging brushstrokes. The rough texture will create dimension.

Use the side of the brush to draw a dark cap.

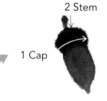

Variation

When drawing a group of acorns, imagine that they've fallen from a tree and landed in a scattered pile on the ground.

Cosmos

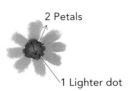

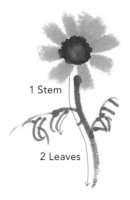

Start with a large dot for the flower center.

2 Petals

1 Lighter dot

Add a bit of lighter gray on top of the dark center, blending the colors together and creating extra volume.

1 Stem

2 Leaves

Use twisty, curvy lines for the flower's stem and leaves.

Shiitake Mushroom

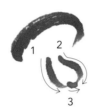

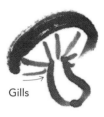

Use a thick and lively brushstroke for the cap of the shiitake.

Use thinner, curved brushstrokes for the stem and base.

Gills

Add some thin gills under the cap.

Matsutake Mushroom

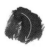

Start with a thick curve.

Use a few more short, thick brushstrokes to fill in the mushroom's stubby cap.

Draw the stem with gently curving lines. Add a small curve for the base.

Everyday Objects

Even mundane items can be transformed into elegant drawings with a brush pen and black ink! Try to keep the shapes and lines simple, even when drawing more complex objects, like vehicles.

Straw Hat

Using a thick brushstroke, draw a semicircle for the hat's crown.

Add a short and slightly curving brushstroke for the base of the crown, and then some rougher, larger curves for the brim.

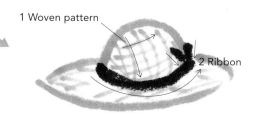

1 Woven pattern

2 Ribbon

Scratchy lines help bring this rustic straw hat to life.

Wind Chime

Start by drawing a narrow oval for the open mouth of the bell.

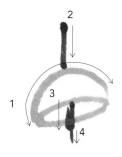

Complete the bell with a thick brushstroke arching up and over the oval. Then use a second color to draw the cord holding the wind chime and the clapper inside the bell.

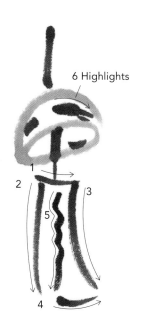

6 Highlights

Use loose, curvy lines for the paper decoration fluttering beneath the bell.

Spinning Top

Start with a narrow oval for the flat upper surface of the top.

To draw the side of the top, tilt your brush and make a single thick, uniform line.

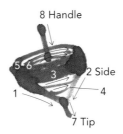

8 Handle
5 6
2 Side
3
1
4
7 Tip

Use diagonal lines for the sides, and then decorate with thin lines. Drawing the top at an angle makes it look like it's actually spinning!

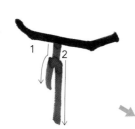

Variation

For a dynamic drawing, add a pale "ghost" where the top used to be just a second ago and grand, swooping lines to represent the toy's speedy path.

Bicycle

Use sharply angled brushstrokes of uniform width for the handlebars.

1 2

Add a short, straight pole beneath the handlebars, and then two legs. Leave one leg shorter so you can draw the wheel later.

1 4
2
3

Now draw the diagonal and straight poles that make up the frame of the bike.

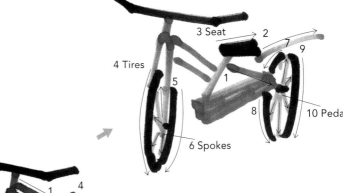

3 Seat 2
7
9
4 Tires
1
5
8
10 Pedal
6 Spokes

Draw everything but the tires with straight, uniform lines. Don't forget the seat and the pedal!

Car

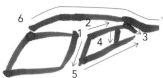

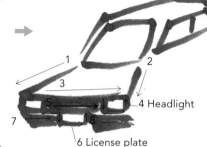

Start with
a slanted
square
for the
windshield.

Draw the windows with
sharp, angular lines, and
then add a roof on top
using one long brushstroke.

4 Headlight

6 License plate

Add some uniform
horizontal brushstrokes
for the bumper, leaving
empty rectangles for
the headlights and
license plate.

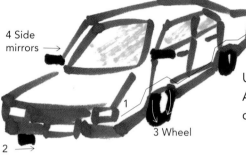

4 Side
mirrors →

1

2 →

3 Wheel

Use a darker shade of ink for the wheels and side mirrors.
Add some rough brushstrokes to the windows in a lighter
color to really make them shine.

Sailboat

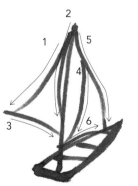

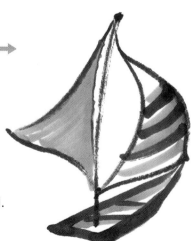

Start off with the side
of the boat closest to
the viewer, drawing
it with thick angular
brushstrokes.

Use thinner lines
for the far side of
the boat and any
interior details.

Draw the sails with
dramatically curved
brushstrokes to show
them billowing in the wind.

Use gray and black shading
to decorate the sails.

Bus

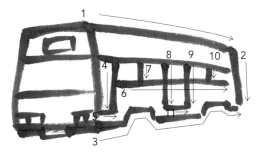

Start with a simple trapezoid, with one side at a slight angle.

Use angular lines to block out the windshield, headlights, and display.

Draw the top and side of the bus with thick, slanted brushstrokes. Leave some space for the wheels when drawing the bottom of the bus.

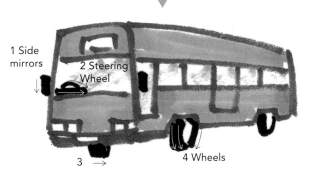

Use a light gray to shade the body, and then add shadows to the windows and door.

Airplane

Start with an arched curve.

Draw the body, windshield, and nose of the plane with softly curved brushstrokes.

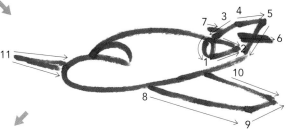

Use more angular lines to draw the engine, tail, and wings.

Give the plane curved windows to suggest the rounded form of its body.

INSPIRATION GALLERY

You can use your brush pen illustrations to create one-of-a-kind stationery, gift wrap, and presents. The following images are meant to provide inspiration; but remember, the possibilities are endless!

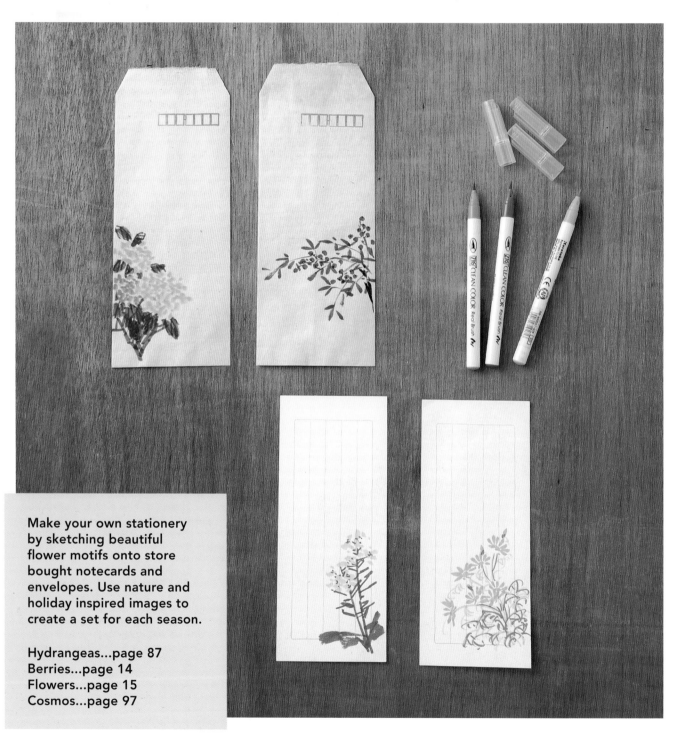

Make your own stationery by sketching beautiful flower motifs onto store bought notecards and envelopes. Use nature and holiday inspired images to create a set for each season.

Hydrangeas...page 87
Berries...page 14
Flowers...page 15
Cosmos...page 97

Decorate simple bookmarks with cute animal illustrations to make reading fun! Tear thin strips of paper, punch a hole, and embellish with ribbon or fabric scraps. These bookmarks make great gifts for bookworm friends.

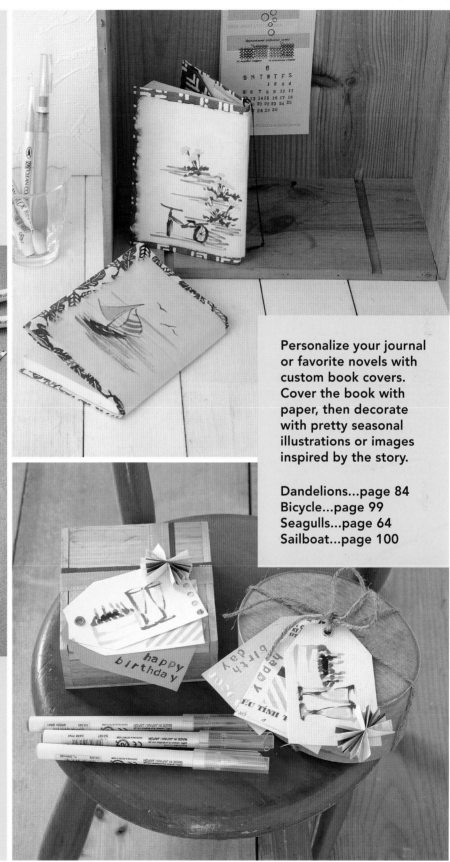

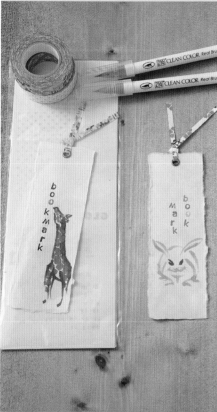

Personalize your journal or favorite novels with custom book covers. Cover the book with paper, then decorate with pretty seasonal illustrations or images inspired by the story.

Impress your friends and family with handmade birthday cards and gift wrap. Festive illustrations, such as birthday cake and champagne, are perfectly suited for celebrations.

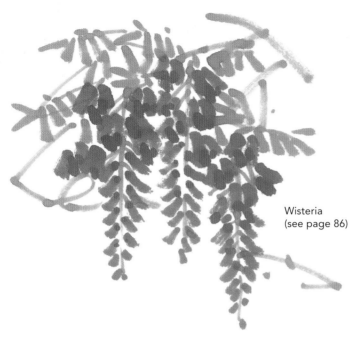

Wisteria
(see page 86)

RESOURCES

Blick Art Supply

www.dickblick.com
Largest and oldest provider of art supplies in the US

JetPens

www.jetpens.com
Online stationery store with a wide selection of Kuretake and other brush pen brands

Kuretake

www.kuretakezig.us
US website for the brush pens used in this book

Oriental Art Supply

www.orientalartsupply.com
Art supply store with a wide selection of Xuan paper and other brush painting and calligraphy supplies